CW00450127

SECRET
MIDDLESBROUGH

Paul Chrystal &
Stan Laundon

AMBERLEY

About the Authors

Paul Chrystal was educated at the universities of Hull and Southampton where he took degrees in Classics. He has worked in medical publishing for thirty-five years, but now combines this with writing features for national newspapers, as well as advising visitor attractions such as the National Trust's *Goddards* house, the home of Noel Terry, and *York's Sweet Success*. He appears regularly on BBC local radio and on the BBC World Service. He is the author of forty plus books on a wide range of subjects, including histories of Middlesbrough, Hartlepool, York and other northern places, social histories of tea and of chocolate, a history of confectionery in Yorkshire and various aspects of classical literature and history.

Stan Laundon was a presenter and producer on BBC Radio Teesside for many years. He was a part of the entertainment industry during the sixties, working with pop singer Joe Brown, as well as being a columnist for the magazines *Beat Instrumental* and *Beat Monthly*. He also worked as a journalist for the *Express* & *Independent* group of newspapers in East London. He is co-author of *Hartlepool Through the Ages*, published in 2014.

Stan insists that his main claim to fame is that he was the first ever disc jockey in the UK to play Chris Rea on the radio. He was involved in charity work for the Guide Dogs for the Blind, Hartlepool & District Hospice and the RNLI in Hartlepool. For information on Hartlepool's history, news and information about the town, and some stunning photography, go to Stan's fascinating website: www.stanlaundon.com.

First published 2015

Amberley Publishing
The Hill, Stroud, Gloucestershire, GL5 4EP
www.amberley-books.com

Copyright © Paul Chrystal & Stan Laundon, 2015

The right of Paul Chrystal & Stan Laundon to be identified as the Author of this work has been asserted in accordance with the Copyrights, Designs and Patents Act 1988.

ISBN 978 1 4456 4676 3 (print)
ISBN 978 1 4456 4677 0 (ebook)

British Library Cataloguing in Publication Data.
A catalogue record for this book is available from the British Library.

Typesetting by Amberley Publishing.
Printed in Great Britain.

Acknowledgements

Thanks go to Araf Chohan for permission to use a number of images from his prodigious collection. Araf's latest book is *Middlesbrough St Hilda's – Timelines.*Thanks too to Redcar & Cleveland Borough Council for allowing reproduction of the Redcar images, and to Alan, Jonathan and Andrew Musgrave for letting me use the images they took on the Dunkirk-Redcar set of *Atonement*. My thanks to Patrick Brennan for the Bolckow, Vaughan & Co Munitionettes team photograph, published in his *The Munitionettes: A History of Women's Football in North East England During the Great War.* Intriguing details on the Second World War bombing raids on Middlesbrough can be found at the obscurely named *www.englandsnortheast.co.uk.* – a superb compilation by Roy Ripley and Brian Pears. Maurice Friedman, British Music Hall Society, has kindly allowed us to use the picture of the cast at the Theatre Royal; Jacki Winstanley, marketing manager at Beamish, The Living Museum of the North, gave permission for me to use a number of images and Peter Barron, editor at the *Northern Echo* let us use their archive photographs. Barry Jones, archivist and historian for the Globe Theatre allowed us to use the Guy Mitchell image while Colin Bradley of the Road Runners gave permission to use the photo of the band (including Paul Rodgers) on the back of an iconic 1954 Ford Consul convertible. Thanks finally to Tim Hardy for the wonderful pictures of Stockton and the graceful Infinity Bridge. Co-author Stan Laundon has taken some truly stunning photographs that appear throughout the book.

Preface

Middlesbrough has one of the most interesting social histories in Europe with an industrial heritage that is a veritable microcosm of industrial life at the end of nineteenth and early twentieth-century Britain. – likewise, Stockton and Yarm further down the Tees where industry eventually gave way to relatively quieter ways of life. Redcar, the fourth town covered in this book, is noted for its tourism and, like Middlesbrough, its iron and steel. Much of the history of these places is familiar, to resident and visitor alike. There remains, however, much that is shrouded in mystery, much that has, more by accident than design, lain 'secret', bits of history that fewer people know much about. *Secret Middlesbrough* exposes some of the more obscure and less celebrated aspects of the chequered pasts of the towns of Middlesbrough, Stockton, Yarm and Redcar. They are no less interesting for that – in fact they are fascinating and make a refreshing change to the standard stuff usually available.

Our 'secrets' take in a host of characters such as Henry Bolckow, John Vaughan, Gertrude Bell, John Walker, Chris Rea, Lewis Carroll and Paul Rodgers. You will visit the Eston Hills, the Transporter Bridge, the Infinity Bridge at Stockton, and Redcar's Beacon and Yarm Fair.

The authors have published a number of books on the area; we have deliberately avoided using images which have already been published in any of these.

Also available by Paul Chrystal

Hartlepool Through Time
Hartlepool Through the Ages (with Stan Laundon)
Redcar, Marske & Saltburn Through Time
Lifeboat Stations of the North East from Sunderland to the Humber
Old Middlesbrough (in press)
North York Moors Through Time
The Vale of York Through Time
Barnard Castle Through Time
Hartlepool The Postcard Collection (with Stan Laundon – in press)
Northallerton Through time

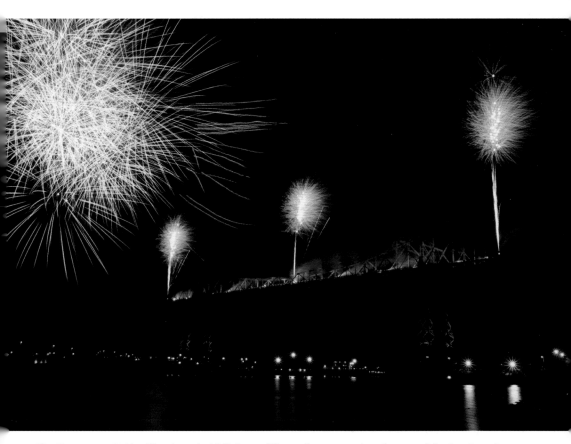

The Transporter Bridge illuminated with lights and fireworks – a stunning photograph by Stan Laundon.

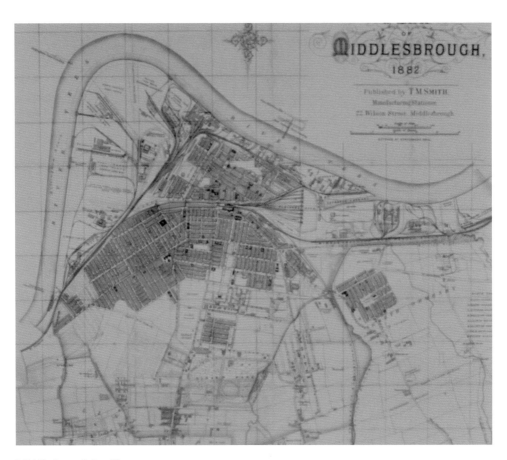

Middlesbrough in 1882.

Contents

Introduction 8

Middlesbrough: Iron & Steel 17

Middlesbrough: Steel River & Iron Bridges 27

Middlesbrough: People & Places 38

Stockton-on-Tees 65

Yarm 73

Redcar 80

Introduction

Middlesbrough's origins are deeply religious: they go as far back as 686 BC when St Hilda instructed St Cuthbert to set up a monastic cell on the site of the future town. In 1119 Robert Bruce, 1st Lord of Cleveland, granted the church of St Hilda of Middleburg to Whitby; the church later became known as Middlesbrough Priory. The Saxon name 'Mydilsburgh' is the first recorded form of Middlesbrough's name we have; 'Mydil' could be the name of an Anglo-Saxon chieftain, or a reference to the town's location, midway between the Christian Meccas of Durham and Whitby.

The transformation of Middlesbrough from the rural farm and its four or five families with twenty or so agricultural inhabitants in 1800 to the iron and steel town – Ironopolis – that it became in the latter part of the same century portrays an almost complete social and urban history of England. Horse-drawn ploughs and clucking hens were replaced by clanking shipyards and iron foundries erupting with fire and smoke. By comparison, down the river at Stockton in 1801 the population was 3,700, over the river at Hartlepool 993, seaside Redcar 431 (excluding Coatham, then one of the most important fishing villages in the region with a population of 680 people)

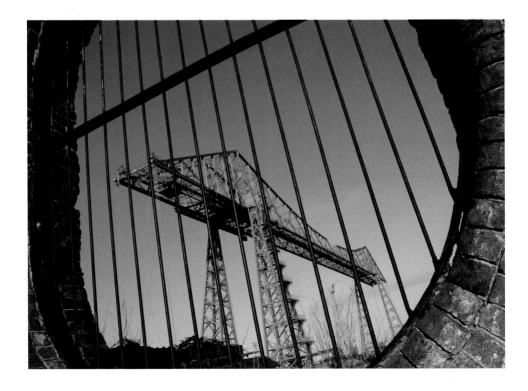

while the little market town Yarm sustained 1,300. Middlesbrough changed beyond recognition. From the middle of the eighteenth century Stockton began to decline in the face of Middlesbrough's explosive growth: the area went from farm to furnace, from cattle to crane.

For Middlesbrough, Stockton and Yarm the River Tees was central to their growth and development, and, in the case of the latter two, to their eventual decline. The river is tidal up to Worsall – 4 miles above Yarm, 10 above Stockton and 22 above the Gares in the estuary. Before the Gares there were treacherous sandbanks and these, combined with the dangers of the Tees Bay and the circuitous silt and sand hazards encountered en route, meant that something had to be done if river trade was going to flourish. The two meander eliminating cuts – Mandale and Portrack, and the estuary breakwaters - did much to improve things, while also shortening the distance to the sea.

How, and why, did this local industrial revolution take place? The spark was provided first by the momentous event that was the opening of the Stockton and Darlington Railway. Then secondly by Darlington Quaker Joseph Pease – banker, coal mine owner and Stockton & Darlington Railway shareholder who happened to be one of the promoters of the new railway and was looking for a suitable site from which to export the coal, mainly to London and the south, that was cascading out of the Durham coalfields.

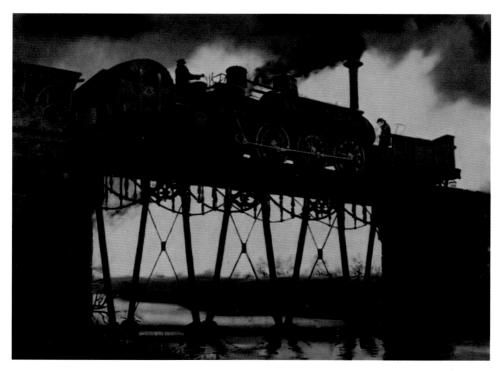

The Gaunless Bridge at West Auckland on the route of the Stockton & Darlington Railway. The painting by John Wigston shows engine #23 crossing what was the first iron railway bridge, originally built by George Stephenson for horse-drawn traffic. The bridge can be seen at the National Railway Museum in York.

In 1829, Joseph Pease and his six Quaker partners bought the 500-acre Middlesbrough farm estate for £30,000. Stockton-on-Tees had largely failed as a port and as an industrial town; bigger boats meant that it was unable to cope with the increasing river trade while growing competition from the Clarence Railway on the north bank at Port Clarence was eating into its markets. Pease got on a boat and sailed down the Tees, determined to do something about the bleak situation and find the best place for his coal staithes. He soon found somewhere and he, with the consortium of Quaker businessmen, purchased the 527-acre farmstead and its surrounding land from William Chilton who himself had bought the farm land for £15,750 in 1808. Pease then established the Middlesbrough Estate Co. or the Middlesbrough Owners. Much of his new land was unyielding salt marsh but Pease had the vision to see its potential for development. A new coal port sprang up on the banks of the Tees, and a new town was established to provide labour for the port; it was named Port Darlington. If anything, Pease seriously underestimated the possibilities: in 1826 he forecast that 10,000 tons of 'black diamonds' would be exported every year through Port Darlington; in the event, the figure for 1830–31 exceeded 150,000 tons. It was no coincidence that in 1830 the S&DR was extended to Newport on the Tees in Middlesbrough thus forming a vital through-route for coal from Durham. Within a year, 150,000 tons of coal a year was exported from Middlesbrough, rising to 1,500,000 tons by 1840. Middlesbrough was well and truly on the map.

The 1841 census shows that sixty-seven men were employed at Port Darlington.

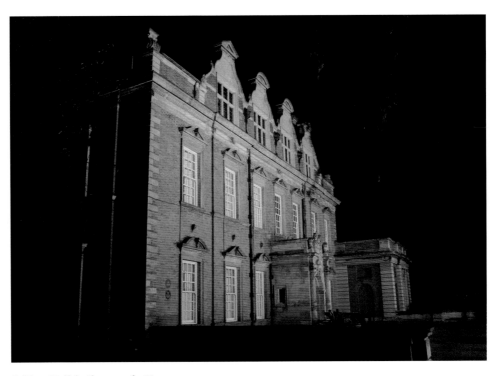

Acklam Hall, built around 1680.

More than 100 sailing ships reportedly docked on just one tide, and to expedite registration and beat the competition, crew would be put ashore at Redcar and Huntcliffe, and make their way to Port Darlington by land to register their arrival. There was competition from elsewhere, not least from the Tyne and Wear. Nearer home, the first cargo of coal from Port Clarence left in January 1834 while Hartlepool's first ship full of coal set sail in July 1835. Hartlepool had the advantage of being a sheltered, south-facing harbour, unaffected by the problems that plagued the less friendly Tees Estuary. The biggest problems were the same as those which killed off Yarm and Stockton: the increasing size of ships, the shifting tides and sands and the shallow water.

Within a year the population of Middlesbrough approached 2,500. With remarkable prescience, Pease predicted that 'the bare fields would be covered with a busy multitude with vessels crowding the banks of a busy seaport'. Agglomeration economics prevailed: Port Darlington quickly became a magnet for support businesses swallowing up premises and land; shipping companies, brickyards, potteries, merchants, shop and innkeepers, blacksmiths, welders and other tradesmen all converged. Men were taken on, staithes and wharves were built, workshops went up and lifting engines were installed. Middlesbrough Dock opened in 1842 and was bought out immediately by the S&DR. So great was the change and the growth that it compelled one historian, J. W. Ord, to describe Middlesbrough as one of the commercial prodigies of the nineteenth century: 'To the stranger visiting his home after an absence of fifteen years, this proud array of ships, docks, warehouses, churches, foundries and wharfs would seem like some enchanted spectacle, some Arabian Night's vision.'

The town's population increased thirty-six fold (3,642 per cent) between 1831 and 1841, from 154 to 5,463. By 1851 all this new industry and the immigration it triggered meant that emergent Middlesbrough's population had mushroomed to 7,600, succeeding Stockton as the principal port on the Tees. The Post Office found it hard to keep up: rivalry between the two towns was fuelled when the Post Office continued to insult Middlesbrough as 'Middlesbrough, near Stockton'. 'Yarm was, Stockton is, Middlesbrough will be'; never were truer words spoken.

All of these people obviously needed somewhere to live; they were mainly young adults and their families were likely to grow and create demands on the local provision of schools, healthcare, churches, social and recreational facilities and the like.

The new town and its planning shared some characteristics with the growing number of model industrial towns springing up; they are more familiar to us because of Bournville (Cadbury), Saltaire (Titus Salt's mills), Port Sunlight (Lever Brothers), New Earswick near York (Rowntree), and the new towns such as West Hartlepool nearby. Middlesbrough was deliberately built to look symmetrical, with four main streets radiating from a central square where the town hall stood: these streets were pragmatically named North, South, East and West Streets. Commercial Street, Stockton Street, Cleveland Street, Durham Street, Richmond Street, Gosford Street, Dacre Street, Feversham Street and Suffield Street all followed, laid out on a grid-iron pattern with the Market Square its epicentre. Social amenities such as the church were crucial components and took pride of place. The Quaker owners contributed to the cost of the land for and the building of St Hilda's parish church although it was not entirely altruistic: the church was seen as a weapon in the fight against the intemperance already

quite prevalent in Middlesbrough. The residential area was divided into plots; those who bought a plot were personally responsible for street paving, sewers and roads. As in the industrial villages, the houses here were subject to strict building specifications establishing the minimum width of roads, height of houses and size of windows.

The homeowners too were subject to rules and regulations: keeping the streets swept, muzzling dangerous dogs and driving carriages responsibly. Letting off fireworks, cock-baiting and throwing out dung or rubbish into the streets were all banned. Early Middlesbrough was indeed becoming an established model town. Historian William Lillie describes it as steady and flourishing in his *The History of Middlesbrough*. Middlesbrough's spectacular growth is unparalleled in English history, so it is hardly surprising that it has been described as the 'oldest new town' in England.

The early 1840s were good years. Apart from St Hilda's, the Wesleyan Methodist chapel opened, followed by Richmond Street Primitive Methodist chapel. Adult education and insurance blossomed too with the opening of a mechanic's institute and the establishment of an Oddfellows District; Friendly Societies proliferated. The British and Foreign School Society opened the first new purpose-built school.

Despite Pease's breakthrough voyage, it was not all plain sailing. Ironically, the revolution that was the railways might have been the death of newborn Middlesbrough, strangling it at birth. Middlesbrough was dependent on coal, but coal could now be shipped more cheaply by rail than by sea, so this eventually had major consequences for the town's role as a coal exporter and the value of that commodity to the town. The coastal coal trade drifted back into the harbours of Hartlepool and Newcastle. Something had to change if Middlesbrough was to survive and thrive.

Heads down for art at the high school.

The Middlesbrough Owners were shrewd enough to see that a new industry was needed, not just to secure the town's future prosperity but to ensure its very existence. In 1839, Henry Bolckow, an accountant from Germany, and John Vaughan, an experienced ironmaster from Worcester, were looking for a site for a new ironworks. The following year John Pease sold them land on Vulcan Street for £1,800. Middlesbrough's golden age of iron and steel had dawned.

As we have seen, relative to Middlesbrough's rise, Stockton was on the slide. Stockton has its ancient origins with the Anglo-Saxons. Later, the bishop of Durham, Pudsey, made his residence in Stockton Castle a glorified, fortified manor house.

Stockton's famous market goes back to 1310 when Bishop Bek of Durham granted a market charter in perpetuity 'to our town of Stockton a market upon every Wednesday for ever'. From then it developed into a bustling little port, exporting wool and salmon and importing wine for the rich; it was still very small, though, with a population of around 1,000, which did not change for centuries.

In 1644 The Scots captured Stockton Castle and occupied it for two years; Cromwell destroyed it at the end of the Civil War. The famous town house was built in 1735 and Stockton's first theatre opened in 1766. In 1771 the Bishop's Ferry was replaced by a five-arch stone bridge – the lowest bridging point of the Tees until the Middlesbrough Transporter Bridge opened in 1911. The Industrial Revolution had a dramatic and pronounced effect on Stockton, changing it from a modest market town to a centre of heavy industry.

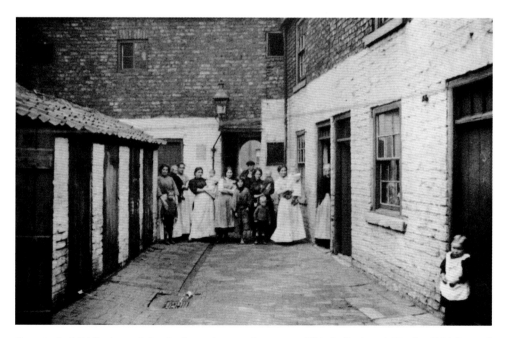

Poverty in Middlesbrough in the late nineteenth century. This is Graham's Yard, off Richmond Street. The whitewashing was an attempt to brighten things up, but the privies on the left failed to provide the best of views.

In 1887, John Bartholomew's *Gazetteer of the British Isles* described Stockton-on-Tees as follows:

> Stockton: manufacturing town, river port, parish and township, , on river Tees, 4 miles from its mouth, 4 miles SW of Middlesbrough and 236 from London by rail; population 42,242; 4 Banks, 2 newspapers. Market-days Wednesday and Saturday. Stockton was long under the bishops of Durham, one of whom built its castle, which was dismantled after the Civil War, and has now totally disappeared, its last remains having been removed in 1865. Its commerce rose to importance through the decline of Hartlepool about 1683, and was checked by the recent rise of Middlesbrough, but is still large and flourishing. The mfrs. formerly consisted almost exclusively of linen and sailcloth, but the development of the iron mines of Cleveland has led to a rapidly increasing trade in iron smelting and rolling, iron shipbuilding, and the mfr. of iron rails, iron bridges, marine engines, boilers, gasholders, and Co. There are also potteries and bottle works. It returns 1 member to Parliament.

Shipbuilding began in the mid-seventeenth century with sixty ships built between 1780 and 1800; the yards were at Smithfield and near to Stockton Bridge.

By the end of the eighteenth century Stockton had taken over from Yarm as the principal port on the Tees; bigger boats and tides saw to that. We know that in 1767 9,600 tons of grain, 1,400 tons of butter, cheese, pork and ham, seventy tons of ale, 900 tons of alum, and 900 tons of other products left the port. Grain was in decline, though, with 124 ships in and out in 1760, falling to twenty-three in 1769. The 1771 bridge opened up markets in Cleveland and reinforced Stockton as a market town.

In the years between 1801 and 1951 Stockton's population increased from 4,177 to 74,000 – which is an eighteen-fold increase; Eston saw a sixty-three times increase while Middlesbrough showed an astonishing 6,000 times.

In 1260 a Dominican friary was established in Yarm where there was a timber bridge over the Tees from 1200. In the twelfth century trade flourished with Flanders, France and Scotland exporting local grain, Dales lead, and wool hides and salt; wine was imported. In 1207 King John granted Yarm a weekly market and two annual fairs from which Yarm went from strength to strength. So wealthy did it become that Scottish raiders sacked the town five times in the fourteenth century under Robert the Bruce. In 1400 Bishop Skirlaw of Durham built the stone bridge which still stands today. The growing size of ships, however, was Yarm's downfall: the bigger they got the fewer were able to navigate down to Yarm to and from the sea. Yarm could only handle ships of between sixty and one hundred tons; the journey took four tides. At Stockton, 150 tons and two tides was becoming the norm: Yarm declined, giving way to Stockton and later to Middlesbrough.

Redcar it seems was originally founded on marshland: the 'car' in its name derives from the Old Norse word 'kjarr' which means marshland. Redcar, called Redker in 1165, Ridkere in 1407 and Readcar in 1653 may denote the red coloured marshland from the red stone in the area, or reedy marsh from the Old English 'hreod'.

Coatham had a salt works in the seventh century. Our first records are of a fish market in Redcar in 1366. The first local market was in Coatham next door, dating from

1257 when Marmaduke de Thweng obtained a King's licence for a market and fair. In February 1922 the market was revived with fifty stalls on the south side of the High Street, moving to West Dyke Road and closing in 1956. In 1808 the Revd Graves wrote in his *History of Cleveland* that Redcar was 'a considerable fishing town situated close upon the beach', reminding us that it 'consisted formerly of a few miserable huts only', inhabited by fishermen and their families, but is now a place of fashionable resort for sea-bathing. He thought the increasing number of lodging houses 'neat and commodious' but was astonished by the mountain of drifting sand piled up against the houses and on the roads. Graves, however, thought Coatham the more genteel, the more upmarket of the two. William Hutton's *Trip to Coatham at Eighty-Five* published in 1810 describes Redcarre as a 'poor fysher towne'; a salmon fishery was established in Coatham in 1830. Hutton thought the inhabitants clean and well-mannered with not a 'ragged person' to be seen. At the time both villages (still divided by a mile or so of green belt) comprised one street with Redcar boasting 160 or so mainly mud-walled houses on both sides and Coatham seventy houses on one side of the street. Those sand drifts were a major problem, a nuisance and a hazard.

People came for the extensive beach and for the sea. As the population of Middlesbrough and Stockton ballooned so did the day trippers and holiday makers. As Teesside iron and steelworks proliferated, so did the number of senior management coming to Coatham and Redcar in search of a desirable place to live – away from the smog, and all those workers. Bicycles, tricycles and baby-carriages could be hired for the day by the visitors and your guest house would even bring in a piano if you so desired. There were boat trips to Seaton Carew and to Saltburn. A lending library and a small theatre opened.

For the inhabitants, there were two bath houses – Mr Carter's and Stamps', joined later by Skinner's on Lord Street and Spence's on Cleveland Street. The poorhouse was two cottages before inmates were shunted off to the workhouse at Guisborough. Guisborough, however was just 'an old tumbledown cottage', and was 'no regular workhouse but a house for the reception of paupers'. A paid manager was employed, but not for very long. One lame Guisborough pauper was 'offered' the post under threat of his allowance being stopped if he refused. Another seventy-five-year-old took it on but found it so demanding that he cut his own throat.

Sir William Turner was born in Guisborough. He made his fortune in wool and was Lord Mayor of London and an MP in 1669, supervising the rebuilding of the capital after the Great Fire in 1666. Turner spent much of his money building and running Sir William Turner's Hospital from 1676 – almshouses which cared for ten elderly men, ten elderly women, ten boys, and ten girls. Turner died in 1692, bequeathing £3,000 to his nephew Cholmley Turner to pay for a free school in Coatham; this materialised as the school building which now houses Kirkleatham Old Museum (Coatham was part of Kirkleatham in those days). The school was vacated in 1869 when the grammar school was built. Turner's name resurfaced in Sir William Turner's Sixth Form College in Redcar Lane; it lives on today in the £3.94 million Higher Education Centre at Redcar & Cleveland College nearby .

Smuggling was rife here and emotions ran high. In 1775 the revenue man for Coatham, John Ferry, received the following threatening letter: 'damn you and damn

you Ferry and Parks, blast you Ise, you say you will Exchequer all of Redcar but if you do damn my Ise if we don't smash your Brains out ... keep off the sands or else.' When Old Pott's Cottage – the last of Redcar's ancient cruck cottages dating back to the early sixteenth century at No. 118 High Street – was demolished in 1911, a smuggler's 'dark cupboard', or gin cupboard was discovered.

Everything changed at Redcar and Coatham in 1846 when the railways eventually arrived. As we have seen, tourism had come in the form of thousands of visitors from the Middlesbrough area, West Yorkshire, the north of England and Scotland, all seeking the 8 miles of sands stretching from South Gare to Saltburn and the usual entertainments. In 1863 efforts were made to tidy up the town and rid it of the sand drifts blowing down the High Street and in the roads leading off: 'The Spring cart of the farmer or tradesman and the chariot of the aristocrat now bowl along the street without the least impediment' according to Tweddel in his *Visitor's Handbook to Redcar, Coatham and Saltburn*. As with Middlesbrough, the town was energised and industrialised by the discovery in around 1850 of iron ore in the nearby Eston Hills. The small model industrial village of Dormanstown, or Dormanton as it was officially known, was built to accommodate workers at Dorman Long steel plant. Politically, Redcar Borough Council was the result of an amalgamation in 1922 of Coatham and Redcar. This lasted until 1974 when it became part of Teesside Borough Council.

Middlesbrough: Iron & Steel

Quality Ironstone, Henry Bolckow and John Vaughan

Fortuitously, in 1841, Henry Bolckow, a German who had come to England in 1827, formed a partnership with John Vaughan, then the ironmaster at the Walkergate works in Newcastle. With money to spare, Vaughan persuaded Bolckow to invest in the up-and-coming iron industry. In 1840, after rejecting Stockton, they in turn were persuaded by John Harris, a colleague of Pease's, to open a puddling furnace and a bar mill at Vulcan Street in Middlesbrough, for the processing of pig iron from Scotland. Their iron ore was of poor quality. As this was stunting their growth and profitability, the pair opted to make their own pig-iron. In 1846 they opened four blast furnaces at Witton Park Iron Works, the first ironworks in the northeast of England, 20 miles (32 kilometres) to the west of the town. Initially, they naively tried to save costs by using spoil – cheap slag from the coal mines nearby – but the quality of the iron was unsurprisingly inferior; ironstone was then used from Grosmont up in the North York Moors over near Whitby. Pig-iron production increased tenfold between 1851 and 1856.

The transport costs were, however, crippling and needed to be reduced by the excavation of raw materials nearer to Middlesbrough. Bolckow and Vaughan first bought the Skinningrove mines but kept up the search locally. The seemingly inexorable rise of Middlesbrough and the partnership of Bolckow and Vaughan coincided serendipitously in 1850 with the discovery by the firm's geologist, John Marley, of quality ironstone on their doorstep in the Eston Hills overlooking the town. This ironstone had earlier been rejected as being of poor, unusable value. In 1851 they opened mining operations; a branch railway line was built to carry the ore first to Witton Park and later to Middlesbrough. On the strength of this Bolckow and Vaughan expanded their operations into coal mines, limestone quarries, brickworks, gasworks and a machine works.

Before the exploitation by Bolckow and Vaughan, Cleveland iron ore had had a chequered history. In 1745 J. Cookston started using ironstone from Robin Hood's Bay at his Whitehill furnace at Chester-le-Street. Vaughan's obituary, quoted in *Grace's Guide to British Industry* in 1869, gives a long list of what was mostly dissatisfaction:

> In 1811, Mr. William Ward Jackson, of Normanby Hall, sent a couple of wagon loads of ironstone, obtained from his estate, to be tested at Lemington, and had the mortification to be told that it was good for nothing. In the same year, Mr. Jackson, of Lackenby, sent ironstone from the banks of Lackenby, now part of the Eston Ironstone Mines, but it appears to have led to little, if any result. Fifteen years later (1828) the coast from the Tees to Flamborough was examined, at the instance of the Birtley Iron Company, who were

surprised at the slight traffic in iron ore carried on with the Tyne, by means of fishing cobles and small coasters. In the same year, Mr. Bewicke, of Sunderland, discovered the main seam; a circumstance which Professor Phillips acknowledged in the following year. In this year (1829) also, Mr. Charles Attwood of Tow Law Iron Works, met with good specimens of ore in the Hambleton Hills, and predicted that 'Cleveland would become a great iron district when the railway system came to be developed.

In 1832, W. A. Brooks and Mr. T. Y. Hall, of Newcastle, testified that the adjacent rocks of Redcar contained large quantities of iron. In 1833, the Whitby and Pickering railway being in operation, ironstone was again sought for, and fifty-five tons were sent from Grosmont to the Birtley Company's Works, where Cleveland ironstone was first used. The next year (1834) Lord Ward's agent, from Dudley, examined the Rosedale ore, and pronounced it to be limestone, not ironstone. In 1837, some more stone was sent to the Tyne Iron Company, who refused it, saying, 'they were ashamed to see it lying on their quay.' However, in 1839, the Birtley Company again tried the ore, reported favourably of it, and entered into a contract with the Whitby Ironstone Company for as much as 30,000 tons of one lot, at 10s per ton of 22.5 cwt, and a second lot at 9s, which was delivered at the Pelaw staithes. After this time various firms appear to have used Cleveland iron, but its reputation made little way, and the trade was quite divided as to its merits.

Perhaps, though, Marley's discovery was not entirely fortuitous. In 1840 Bolckow Vaughan had already 'collected and shipped to Middlesbrough several thousand tons found on the coast between Redcar and Skinningrove'; Vaughan had a hunch that the same thick seams including the main bed might be inland, in the Eston and Upleatham hills near the railway. On 8 June 1850, Marley and Vaughan walked along the coast surveying it for workable iron ore. They discovered seams of the ironstone running from Staithes inland to the Eston Hills with frequent outcrops.

Marley adds the detail:

Mr. Vaughan and I, having gone to examine the hills for the most suitable place for boring, we decided to ascend to the east, adjoining Sir J. H. Lowther's grounds, and so walk along to Lady Hewley's grounds on the west. In ascending the hill in Mr. C. Dryden's grounds, we picked up two or three small pieces of ironstone. We, therefore, continued our ascent until we came to a quarry hole, from whence this ironstone had been taken for roads, and next, on entering Sir J. H. Lowther's grounds to the west, a solid rock of ironstone was lying bare, upwards of sixteen feet thick.

The nature of the source made for commercial benefits. The ironstone was at the surface, 'which rendered boring unnecessary,' so the rock could be quarried, and carted away in tramway wagons down to a 2-mile extension of the railway. In 1857 Marley described the significance of the find and its likely impact on the region in the *Transactions of the Institution of Mining Engineers*:

To the members of this Institute, this ironstone cannot but be an interesting subject, whether they be mining engineers, coal owners, iron masters, or simply a part of the

public personally disinterested, as I believe that nothing has been discovered, within the last twenty years, having so direct an influence on the landed, railway, and mineral wealth, in the North of England, on the South Durham coal field, and on the iron trade generally, as the discovery and application of this large ironstone district. I suppose it may now be taken as an admitted fact, that the prosperity or depression of the iron and coal trades regulates, in a very material degree, the prosperity or depression of nearly all other commercial pursuits in the same locality.

Iron Ore Mines and the Zig Zag Branch

On 7 August 1848 the first mine in Cleveland had opened at Skinningrove, producing ironstone for shipment by sea to Bolckow & Vaughan's Witton Park Iron Works in County Durham. The seam at North Skelton was 9 feet 6 inches; the mine was 720-foot deep – the deepest in Cleveland. Production began in 1872 and was the longest lasting, not closing until 1964. Rail power was needed if the reserves of ironstone in the area were to be fully exploited. At the Loftus mine the original proposal was for a powered incline, but by April 1864 this idea was rejected in favour of a steeply inclined branch railway from the Cleveland Railway main line at Carlin How. Two reversals were needed to reach the valley floor; the Zig Zag branch opened in May 1865. Everything went well with mining supplies going in and iron ore coming out, but in the 1890s a dispute with the North-eastern Railway led to the mine owners exploring other means of transporting ore to the steelwork, although the branch was still used for transporting domestic coal and pit props. The Loftus Mine closed in 1958.

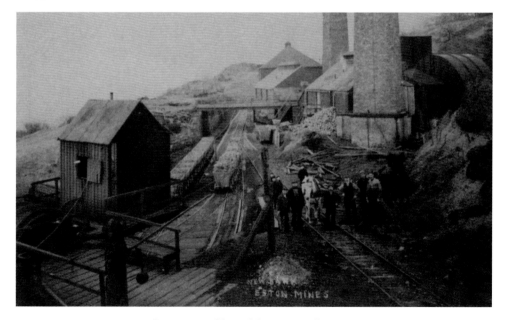

Eston ironstone mine around 1907, owned by Bolckow & Vaughan.

Cholera, Urban Sprawl and Slums

The 1850s saw cholera ravage the town; some streets were condemned as unfit for human habitation. The ideals implicit in the original model town of the 1830s had evaporated in an insatiable demand for more and more housing. As a result, housing was built on the Marshes, which extended out from the river across the railway into the outskirts of town. It was, as the name suggests, marshland and, not surprisingly, frequent flooding and poor drainage compounded the sanitation problems.

In 1854, the blame was placed squarely on the householders by the authorities, demanding improvements to their properties to remedy the 'defective construction' of the town and its chronic overcrowding. As elsewhere, Improvement Commissioners were appointed to improve paving, lighting and drainage. The Improvement Act of 1841 had allowed them to levy 2 s in the pound on owners of houses, buildings and property, which helped the general situation. Firms, including Bolckow & Vaughan, dug deep and distributed emergency food, clothes and fuel to workers and their families.

The urgency to establish the site for iron production and the concomitant urban development had precluded any strategic long-term considerations other than the commercial. The site of the new town and the prevailing winds attracted smoke and other toxic pollutants from the nearby factories. Respiratory disease was rife as a consequence and this, combined with the prevalence of smoking, was the cause of much chronic illness and premature mortality in the town. Without industry and immigration, Middlesbrough would not exist, but it did seem that the town, to some extent, was becoming a victim of its own success.

It was not until the 1850s that utilities started to come on stream: the new gasworks rendered oil lighting obsolete while, in 1850, the Stockton, Middlesbrough and Yarm Waterworks turned on the taps in the Tees Valley.

Ironopolis: 'An Infant Hercules'

In 1851 Middlesbrough's population was 7,431 living in 1,262 houses; this rose in 1861 to 19,416 living in 3,203 houses. It had swallowed up well-established villages like Linthorpe, Ayresome, and Acklam, all of which are recorded in Domesday. By this time Middlesbrough was ahead of the game: their furnaces were the highest and the most productive with the minimum of waste. In 1862 Prime Minister Gladstone had been moved to say: 'This remarkable place, the youngest child of England's enterprise, is an infant, but if an infant, an infant Hercules.' Middlesbrough was now widely, and appropriately, known as Ironopolis. By 1873 the iron field around the town was turning out five and a half million tons of ore and two million tons of pig iron – one third of Britain's total pig iron output. This generated another surge in Middlesbrough's population; in the fifty years between 1841 and 1891 it grew from 5,463 to 75,532. But the world of steel was moving on.

The Future is Bessemer

The introduction of the Bessemer process in the 1850s stopped Middlesbrough in its tracks, particularly the uncharacteristically dilatory Bolckow & Vaughan. Bessemer

revolutionized the industry leading to the massproduction of both mild steel and hardened tooling steel; ultimately Bessemer allowed metals to be produced far more cheaply. Bolckow & Vaughan were slow to adapt; the main reason was the ore: the local iron ore had high phosphorus content and the Bessemer process required pig-iron low in phosphorus to produce viable steel. In 1875 Bolckow & Vaughan finally opened the first Bessemer Steel plant, to meet the demand for much stronger and more resilient metal, and to compete with Sheffield where Bessemer had long been best. The problem was solved by the introduction of the Thomas-Gilchrist process, a variation of Bessemer, which tolerated the Cleveland phosphoros content and allowed Bolckow & Vaughan, and others to produce pig iron for steel making and consigning puddle wrought iron to the past. Ominously, that same year Dorman Long entered the market, producing steel from imported iron. However, the damage was done and by the late 1870s the town was suffering a serious economic downturn with unemployment at record levels.

Iron Bridges

Generally, though, iron was still in great demand in Britain, mainly to supply the rapid expansion of the railways being built in every part of the country. More and more blast furnaces were opened in the vicinity of Middlesbrough to meet this demand. Bridges became the Middlesbrough speciality, with Teesside metal making bridges on the Tees and the Tyne, and Sydney Harbour. 'Iconic' is a word used casually these days for the most mundane of things and humdrum of people. Sydney Harbour, the Tyne Bridge, the Transporter and the Newport Bridge, however, truly deserve that epithet as they are undeniably instantly recognisable global landmarks. Dominant among the Middlesbrough bridge builders was the firm of Dorman Long, who started out in 1875 as shipbuilders, subsuming Bell Bros and Bolckow & Vaughan in the late 1920s.

In 1881 Sir H. G. Reid vividly described how the ironstone of the Eston Hills had been used all around world:

> The iron of Eston has diffused itself all over the world. It furnishes the railways of the world; it runs by Neapolitan and papal dungeons; it startles the bandit in his haunt in Cicilia; it crosses over the plains of Africa; it stretches over the plains of India. It has crept out of the Cleveland Hills where it has slept since Roman days, and now like a strong and invincible serpent, coils itself around the world.

The Iron Rush

Increasing iron and steel production pushed the population to 39,563 in 1871, 55,934 in 1881 and 75,532 in 1891 and in 1901 90,302. By 1900 Teesside was producing 30 per cent of the nation's iron. This 'iron rush' – while lacking something of the romance of gold – shared characteristics of the famous gold rushes in Australia and California. It attracted aspiring workers from all over the United Kingdom: men seeking work flocked to the area as a further eighty mines opened over the next twenty years. Small villages swelled with populations of thousands as coalminers from Durham, Northumberland and Scotland,

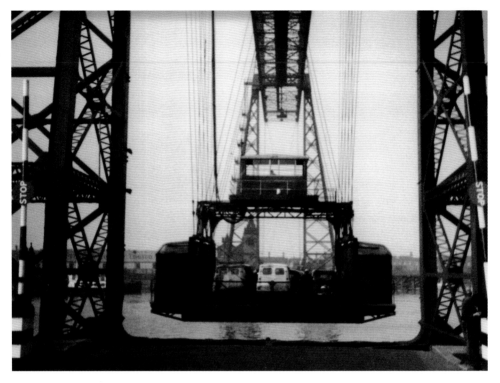

The gondola full of vehicles beneath the Transporter Bridge in the 1960s.

tin miners from Cornwall and farm labourers from Norfolk came together to make this the principal ironstone mining area in England.

Look at the demographics of Middlesbrough as a result of this mass immigration. Before 1851, 73 per cent of Middlesbrough residents came from Yorkshire (Middlesbrough being part of Yorkshire at that time); the 1851 census revealed that over 3,000 people hailed from across Great Britain including around 1,500 people from Durham. By 1871 the Yorkshire element had fallen sharply to 50 per cent due in part to the 551 people who came seeking work from 'foreign parts', notably the colonies, USA and East Indies: the number of immigrants from these places ranged from sixteen people from Germany to one from Jamaica.

Middlesbrough's demographic was interesting in another way: it was very much a male town. Heavy industry was bound to attract rather more men than women; women tended to gravitate more to towns where there was a demand for their labour in domestic service – York and the growing seaside resorts are good examples where women went into service and ran the lodging houses and holiday accommodation. In 1901 Middlesbrough men still significantly outnumbered Middlesbrough women: there were 2,462 more men than women.

Here is Florence Bell's analysis of the employment of girls and women in the Middlesbrough of 1901 as recorded in *At the Works*:

Opportunities lay entirely in shop or small factory work: Dress and mantle makers 380; Tailors 136; Milliners 110; Hosiery-knitters 53; Sweet-boilers 34; Marine stores 25;

Paper-bag makers 15; Beer-bottlers 13; Bottle-washers 10 Salt-packers 9 Upholsterers 7
Lubricating-bag makers 6; Joiners and cabinetmakers 5; Bookbinders 3; Mattress-makers
2; Picture-frame makers 1. Total 811.

The Bishop Auckland Folly

Bolckow & Vaughan were not unassailable. An early catastrophic mistake was made
when they sited their four blast furnaces at Witton Park near Bishop Auckland, using
low quality ore from the nearby mines – Pease baled them out allowing them in 1850
to capitalise on the quality ore found in quantity in the Eston Hills. The company had
many other diverse interests: the steelworks in Manchester; the hematite mines in Spain,
Portugal and Africa; limestone quarries; and a steamer line for transportation – no
wonder the company's stock rose to £2.5 million in fifteen years making it the largest
company ever formed up to that time. Their iron and steelworks extended over 700 acres
along the banks of the Tees.

Iron and Steel Competition

Bolckow & Vaughan were not the only iron and steel producers in town though. In 1843
Edgar Gilkes had the Tees Engineering Works, a rolling stock repair shop and a blast
furnace that soon became Pease and Partners Tees Iron Works and Normanby Iron Works.
Losh Bell & Co (later Bell Brothers) started up a blast furnace in 1851 at Port Clarence. The
Teesside Iron Works opened in 1853 under William Hopkins and Thomas Snowdon from
the Stockton and Darlington Railway. In 1854 the Cochranes from Staffordshire opened
their furnace in Ormesby. Owned by Hamburg born Bernhard Samuelson, Samuelson's
Cleveland Iron Works and Britannia Iron Works were based in Newport, on a 40-acre
site. They focused primarily on iron smelting: its eight blast furnaces were turning out
2,500 to 3,000 tons of pig iron every week by the early 1870s. Dorman Long arrived on the
scene in 1870. Bell Bros were one of the earliest to build blast furnaces, opening in 1873.
Like Samuelson's it soon won a reputation as a specialist pig iron producer, second in size
only to Bolckow & Vaughan in terms of output. By 1875 its twelve 80-foot high furnaces
at the Clarence Iron Works were producing around 200,000 tons of pig iron every year,
approximately 16 per cent of the district's total production.

The End of Bolckow & Vaughan

Vaughan died in 1868 but life had to go on for the company. From *Bulmer's Gazetteer*
of 1890 we can see that in 1888 Bolckow, Vaughan owned six of the thirty-six ironstone
mines in Cleveland and Whitby. By 1887 the company had four of the twenty-one
ironworks in Cleveland, with twenty-one of the ninety-one blast furnaces. In 1905,
the firm produced 820,000 tons of pig iron, 8.5 per cent of Britain's output, and twice
as much as the next largest producer. In 1907 it was one of Britain's largest firms,
with 20,000 employees. However, nothing lasts forever: in 1929 the company suddenly
folded and was taken over by Dorman Long. Causes for this industrial and economic

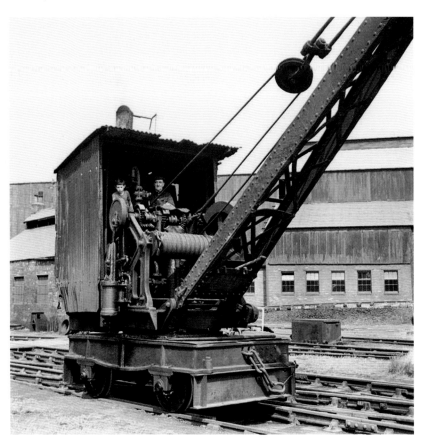

The Stanghow Steam Train Crane Engine and workers. The engine was in service between 1902 and 1936 at Cochrane's foundry in the Ormesby Iron Works.

catastrophe include a failure to embrace new steelmaking technology, a refusal to diversify into profitable steel products such as pipes, sheet steel and shipbuilding plates and a dependence on expensive bank loans in 1918, instead of issuing share capital to invest in its own coal mines.

A Life in Iron

For most men in the region, life was iron and steel or the docks. For the career ironworker, work started at the age of sixteen. He was at his peak between the ages of twenty and forty when his physically demanding labour would earn him his highest wages. After forty he was in decline and would be moved on to less arduous tasks, and the lower wages this brought in. Pollution, noise, dirt, extremes of temperature hot and cold were ever-present workmates. Danger was all around and the injuries – often debilitating – that came with it. Men would typically work eight-hour shifts: 6 a.m. to 2 p.m., 2 p.m. to 10 p.m. or 10 p.m. to 6 a.m. The ironworks never closed: the start-up costs of the furnaces were too great. In 1907 and 1908 many ironworkers were laid off, bringing thousands of residents to the verge of starvation. Public anger and demonstrations led the Corporation to create jobs such as cleaning park lakes

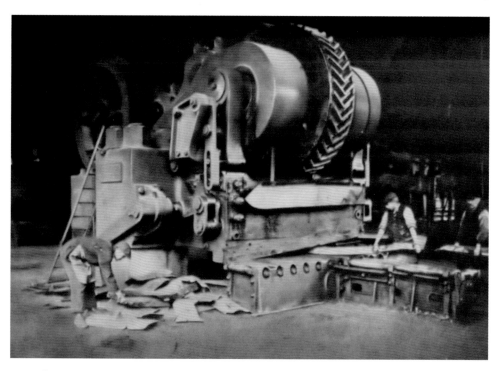

Giant sheers at Bolckow Vaughan in Grangetown.

and street cleaning. The Grand Opera House laid on free dinners and Sunday-night concerts under the Distress Committee.

Steelworks

Between 1946 and 1957 Teesside Steel (including West Hartlepool and Skinningrove) contributed 16 per cent of the national output amounting to 3,200,000 tons in 1956 of which more than 2 million tons came out of Dorman Long. Teesside delivered 25 per cent of the UK's plates, 50 per cent of rails, and 33 per cent of heavy sections. Of the regions' five basic industries in 1954, shipbuilding and repairing and engineering employed 28,000; chemicals 25,000, steel 40,000 and mining 2,000. A total of 95,000 or half of the total workers in the region, 181,300.

The Steel Legacy and the Dorman Museum

Middlesbrough steelworking has left countless, timeless and priceless legacies to the town. In 1904 Sir Arthur Dorman bequeathed the Dorman Museum to Middlesbrough to honour his youngest son, George Lockwood Dorman, an inveterate collector who died of enteric fever at Kroonstad in the Second Boer War. Today the museum houses a world-famous collection of ceramics from the local Linthorpe Pottery, renowned for its iridescent glazes, unique to Europe. The pottery itself had opened in 1834 with its first

order shipped to Gibraltar. The museum opened 1 July 1904 but its collections go back to the late 1860s when members of the Cleveland Literary and Philosophical Society Field Club donated various objects and specimens to create a museum at their premises on Corporation Road.

Tees Tilery

South Bank, 3 miles from Middlesbrough, was originally called Tees Tilery after the brick and tile companies located there. It owes its existence to the establishment of the steelworks of Bolckow, Vaughan, and the Clay Lane Iron Co., but the manufacture of bricks and tiles was equally important to the suburb. The main companies were Johnson & Maw, the North Eastern Brick and Tile Co., and the Cleveland Brick and Tile Co. South Bank was less flatteringly known as 'Slaggy Island', indicative of the fact that it was surrounded by slag heaps.

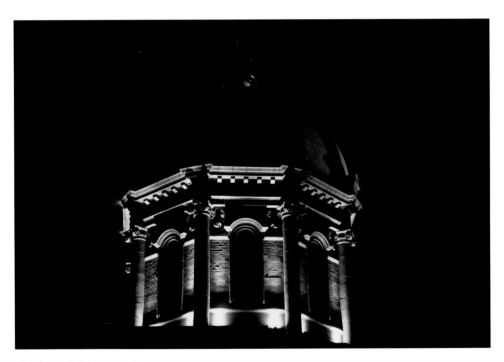

The dome of the Dorman Museum.

Middlesbrough Steel River and Iron Bridges

'The Steel River'

The Tees was now 'the Steel River', immortalised in the 1980s by local Chris Rea in the nostalgic song of the same name.

Bridging the Tees

Wherever you have a river, people will want to cross it for one reason or another. The River Tees is no different. Medieval monks started it all with their ford opposite Newport. When the coal trade came to town in the 1830s, a ferry service was established to cater for the coal and the people employed in it; this was a private enterprise up to 1856 when Middlesbrough Corporation established a public wharf and passage over the Tees. In 1862

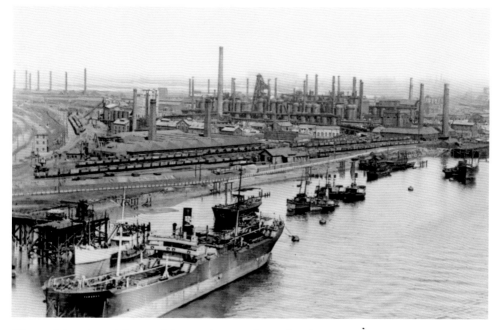

The steel river in 1928, home of ships, railways and countless factories. (*Photo courtesy and © of the Northern Echo.*)

the Ferry Committee launched a steam ferryboat: *the Progress*, a shallow-draught wooden steam ferry licensed to carry 139 passengers. In 1872 things really started to happen when a visionary, Charles Smith, manager of the Hartlepool Iron Works, proposed a bridge on the transporter or aerial ferry principle costing £31,162. In 1874 the corporation ignored him and commissioned the *Perseverance* ferry instead – the first boat to ferry horses and carts over the Tees with 400 passengers at a cost of £2,975. The ferry steamer *Hugh Bell* came next costing £6,050, licensed to carry a massive load of 857 passengers. In 1901 the vexed question of bridging the river with a transporter bridge was revived and then developed from 1906. The Transporter Bridge was finally opened on the 17 October 1911 at a final cost off £84,000. It still stands today, of course, in its iconic magnificence.

Dorman Long

One of the main players now was Dorman Long, founded by Arthur Dorman and Albert de Lande Long after their acquisition of West Marsh Iron Works in 1875. In 1879 they bought the Britannia Works from Samuelson; by 1901 they had 3,000 men on their books; in 1915 they acquired Walker Maynard's Redcar Furnaces and in the 1920s they took over Bell Brothers and Bolckow & Vaughan. In 1916 they opened the Redcar Steel Works. Dorman Long focused on bridge construction: their most famous bridge is Sydney Harbour Bridge (1932), similar to but *not* modelled on the 1928 Tyne Bridge. Dorman Long bridges span the globe and others include, the Omdurman Bridge on the White Nile in Sudan, Grafton

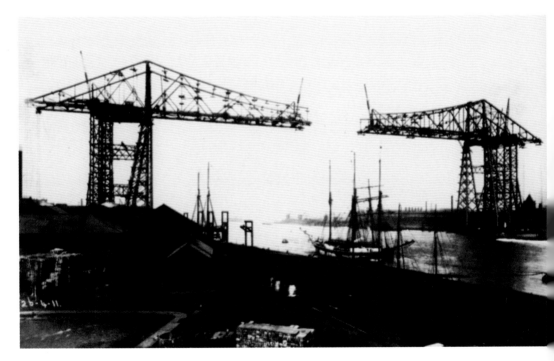

The bridge nearing completion.

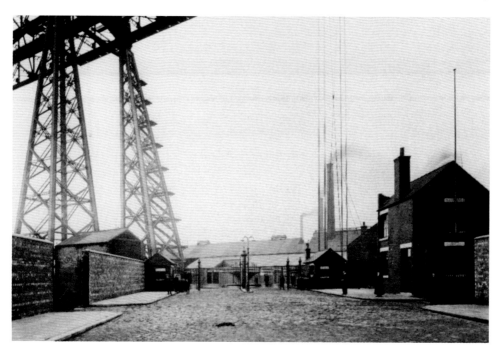

The bridge at Ferry Road – the gates prevented careless drivers driving into the river.

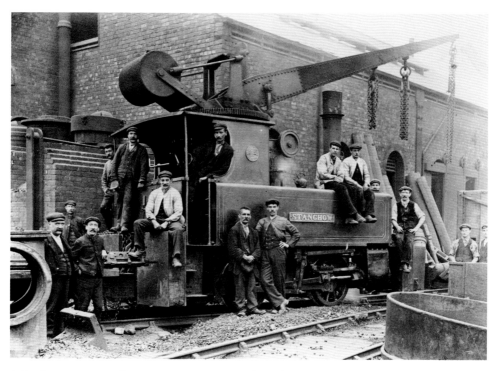

A Booth 3-ton steam rail crane at Dorman Long at the end of the nineteenth century. Note the young boy helping out.

Bridge in New South Wales, Australia, Lambeth Bridge, Memorial Bridge in Bangkok, Storstrom Bridge in Denmark and Chien Tang River Bridge in China.

The Cleveland Bridge & Engineering Co.

Dorman Long was by no means alone. They were rivaled by the Cleveland Bridge & Engineering Co. founded in 1877 in Darlington as a fabrication manufacturer. Like most things in the town the company grew rapidly in size and, like Dorman Long, built bridges all over the world. Transporter Bridge apart, by 1959 they had built the Victoria Falls Bridge, Zimbabwe; Blue Nile Road and Railway Bridge, Sudan; Trent Bridge, Nottingham; Chiswick Bridge; Verrugas Bridge, Peru; Auckland Harbour Bridge, New Zealand and Howrah Bridge, India. Between them, Cleveland Bridge and Dorman Long spanned a changing world in which rail and road communication formed the foundation of economic, commercial and urban progress. And for that they needed bridges.

Newport Lifting Bridge

Newport Lifting Bridge (1934) was England's first vertical lift bridge, boasting a lifting span

The Transporter Bridge looms large at knocking-off time in May 1936.

of 270 feet (82 m) long by 66 feet (20 m) wide. It is made from 8,000 tons of steel and 28,000 tons of concrete with towers 182 feet (55 m) high. The electrically operated lifting mechanism allowed the road to be lifted 100 feet (30 m) in ninety seconds. In the beginning men were employed to man the bridge around the clock, with four of them driving it at any one time from the oak-paneled winding house situated midway along the bridge span. During the 1940s and early 1950s this would happen up to twice a day with an average of 800 vessels per year passing under it. The final lift took place on 18 November 1990 after which the bridge was relegated to an unremarkable, yet still impressive-looking, road crossing over the Tees.

The East Anglian Riots

Competition for work among the tide of immigrants flowing into the area was intense. In 1840 gangs of Irish and East-Anglian workers rioted over work building Middlesbrough docks. Joseph Briggs won the contract for excavating the dock but, when his son divided the work up among a number of sub-contractors, some Englishmen refused flatly to work for the low wages on offer. Peter McKenna, a sub-contractor, hired a number of Irishmen who were promptly attacked and stoned by English navvies. A week later they were pursued by a mob 800 strong and armed to the teeth with spades and pike shafts. A number of Irishmen were left for dead while others sought refuge at Grange Farm, where the tenant was John Parrington. He bravely held the baying mob off with his pistol until the police arrived. A mere twelve English navvies were convicted and imprisoned.

Smith's Dock and the Cruel Sea

Smiths Dock Co., the famous North Shields shipbuilders, opened a dock here in 1907, closing its North Shields Yard in 1909, except for the repair of oil tankers. Smiths Dock was very active in the Second World War, building trawlers which were requisitioned by the Admiralty and converted to armed trawlers for the Royal Naval Patrol Service. Examples include HMT *Arab*, the vessel in which Lt Richard Stannard (RNR) won the Victoria Cross. Smiths Dock was also responsible for the design of the Flower-class corvette, an anti-submarine convoy escort, as immortalised in *The Cruel Sea*. Nineteen were made by the yard and a further 200 by other yards. In 1966 Smith's Dock merged with Swan Hunter & Wigham Richardson to form Associated Shipbuilders, later to become the Swan Hunter Group. The shipyard finally closed in February 1987. Over 900 vessels had been built at South Bank between 1910 and 1987.

Other, earlier yards included Backhouse, Dixon & Co (1864), Candlish, Fox & Co, Harker & Co., and Craggs & Sons.

Chemical Teesside

But the river was not just about steel. Chemicals were and still are the other industry crucial to the region's economy and dependent on the river for the import of raw materials and the export of finished products. Robert Wilson founded a chemical works at Urlay Nook near Egglescliffe in 1833 to produce sulphuric acid and fertilisers; this was

Looking up to the Newport bridge.

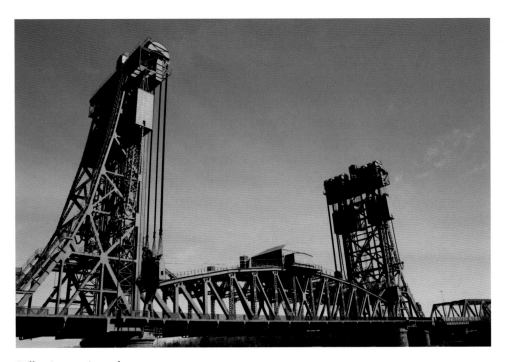

Still as impressive today.

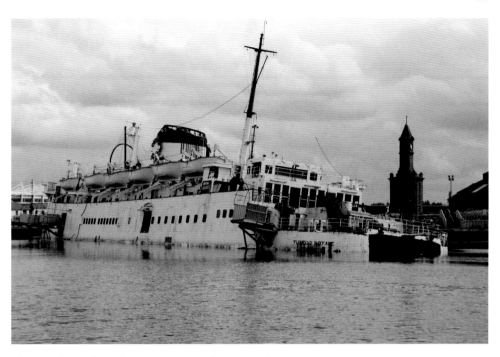

The *Tuxedo Royale* on the Tees waiting to be scrapped in 2015.

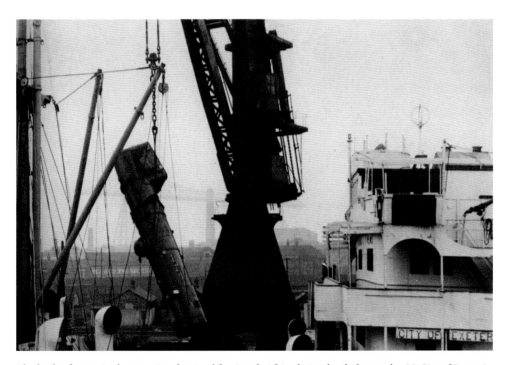

The boiler for a 4-8-2 locomotive destined for South Africa being loaded onto the SS *City of Exeter* in 1947. The Transporter is looming in the mist in the background.

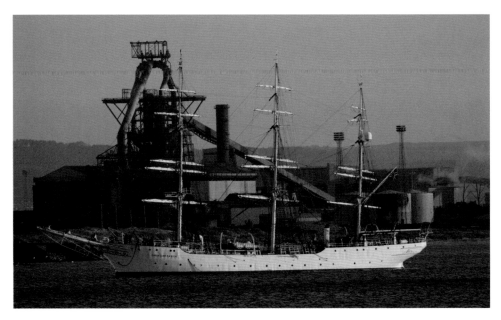

The Norwegian *Christian Radich*, passing the old Corus Steel Works on the River Tees on 1 February 2011. She'd been in dry dock for about a month undergoing some repairs. During August 2010 she took part in the Tall Ships' Races in Hartlepool.

the Eaglescliffe Chemical Co., later British Chrome and Chemicals Ltd. In 1859 rock salt deposits were discovered at Middlesbrough by Bolckow & Vaughan and by Bell Bros while boring for water at 1,206 feet. In 1860 William James established an alkali company at Cargo Fleet and in 1869 Samuel Sadler set up a works nearby. Sadler produced synthetic aniline, alzarin dyes and distilled tar. Sir Samuel Alexander Sadler (1842–1911) was the first Conservative MP for Middlesbrough. He established his firm in 1869 as a tar and wood distillery; in 1880 he bought out the neighbouring company of Jones & Sharp. Products included coal gas, ammonia soda, ammonium sulphate and sulphuric acid. In 1919 Synthetic Ammonia and Nitrates Ltd, in response to the recent German blockade of Chilean nitrates, started production of fertilisers and bulk chemicals. In two years Billingham exploded from a small village to a town of 8,000 inhabitants.

More salt deposits were discovered at Port Clarence by Bell Bros in 1874. In 1882 they set up a salt works at Haverton Hill bringing in salt workers from Cheshire to exploit the resource. Bell Bros were bought by Brunner Mond & Co. of Cheshire in 1890 thus affecting the foundation of Teesside's chemical industry and the demise of competition from Tyneside.

The chemical industry in Billingham was established in 1918 when the government initiated the production of synthetic ammonia, originally intended for the making of bombs for the war. The site chosen was the 700-acre Grange Far. The war had ended before the plant opened and was taken over by Brunner Mond in 1920 for the manufacture of synthetic ammonia and fertilisers. In 1926 ICI was formed by the merger of Brunner Mond with other chemical manufacturers. From 1928 anhydrite or dry gypsum was mined 700 feet below Billingham for the making of fertilisers. Plastics and nylons came

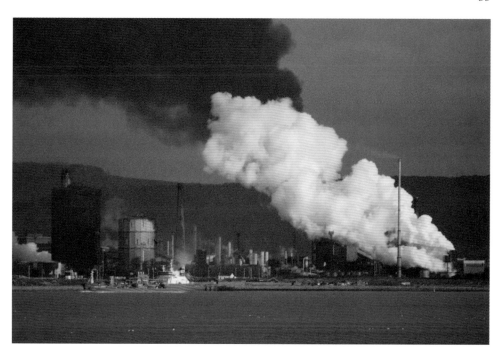

Teesside chemical industries in the estuary today.

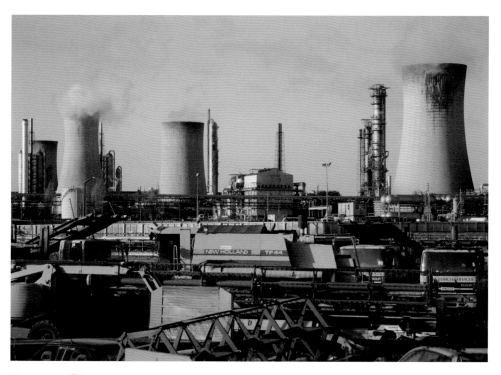

Haverton Hill in 2015.

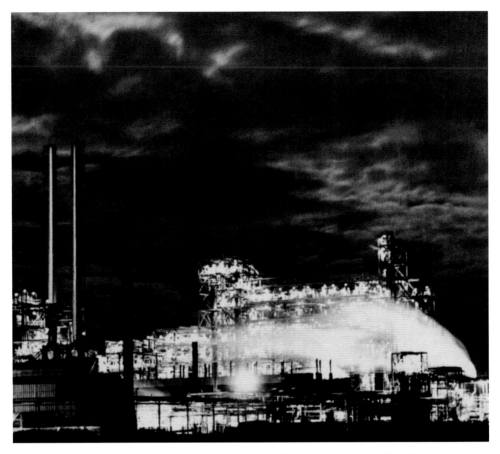

#1 Olefines plant at Wilton in 1954; originally published in *A Brief History of the Chemical Industry on Teesside.*

to Billingham in 1934 and a new plant was opened in 1935 to produce oil and petrol from creosote and coal through the process of hydrogenation. In 1946 ICI Wilton opened near Redcar and in 1962 the site on Seal Sands was reclaimed from the sea.

In 1962, coke ovens originally used for chemicals production at Billingham were replaced by new plants utilising the steam naphtha process – a much cheaper way of making ammonia. Between 1964 and 1969 four great oil refineries were built at the mouth of the Tees, two by Phillips Petroleum and one each by ICI and Shell. Their function was to supply the Billingham chemical industry. The 138-mile pipeline linking chemical Teesside with chemical Runcorn for the transportation of ethylene was built in 1968.

The terminus for the 220-mile-long Ekofisk oil pipeline is at Seal Sands. Oil and gas liquids are piped ashore from the Ekofisk oilfield and processed at what is one of the largest plants of its kind in the world. Ekofisk is an oilfield in the Norwegian sector around 200 miles southwest of Stavanger. It was discovered in 1969 by the Phillips Petroleum Co.; oil is transported by the Norpipe oil pipeline to the Teesside refinery; natural gas goes

to Emden in Germany. The pipeline represents around 50 per cent of the cargo through Teesport, the equivalent of twenty-six million tons a year.

Cargo Fleet – Medieval Port

Cargo Fleet owes its name to the cargoes which passed through the port of Middlesbrough. It predated Middlesbrough by hundreds of years and was important in the Middle Ages as a fishing village called Kaldecotes, meaning 'the cold-shelter cottages' situated where the Marton and Ormesby Becks joined the Tees. Here fishermen or travellers could shelter from the inclement weather. Over time the name changed into Cawker, then Caudgate Fleet and finally Cargo Fleet was adopted. During the eighteenth century, Cargo Fleet also went by the name of Cleveland Port, the place where large ships offloaded their cargoes onto fleets of smaller vessels. From here these smaller vessels were able to continue the journey to Stockton, the main port at the time.

Middlesbrough: People & Places

Boiled Eggs and Blast Furnaces

A post from Tony Donaghy from York on the internet dated 2 January 2004 perfectly encapsulates and endorses what we have seen regarding life in Middlesbrough; little, it seems, had changed by the 1940s and 1950s from what we have witnessed in the latter part of the nineteenth century:

> All of my parents' grandparents came from Ireland, apparently around the 1860s; some came via Consett and Workington. Their early birth/marriage details were found in the RC Cathedral archives. They lived in Italy St and Lloyd St which were part of the old town "over the border" as it was known when I was a child. Both families lived around the Branch (Lackenby) and ended up in South Bank and Grangetown. I was born in 1938 in Redcar but

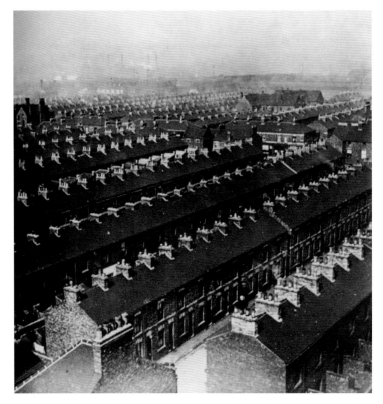

Typical housing with row after row of terraces as taken from the roof of St Paul's church looking north over Newport and the Cannon Street areas.

clearly remember the heavy industrialization of both those towns and similar features along the river in Middlesbrough. I then moved to Billingham about 1945 and on journeys by bus to see my grandmother in Grangetown for Sunday tea, (a boiled egg), passed through almost the whole of industrial Teesside. The journey back in the dark was fascinating with the coke ovens, blast furnaces and chimneys lighting up the night sky. North Ormesby, Central Middlesbrough and Newport Road seemed to have a pub on every corner and most had children playing outside whilst presumably mam and dad were inside.

Joined at the Hip

Henry Bolckow and John Vaughan were much more than successful business partners; Asa Briggs likened them to Siamese twins. They lived next door to each other near their Vulcan Street foundry and they married sisters Miriam and Eleanor Hay; they were both mayors of Middlesbrough and magistrates, and, finally, in an act of unparalleled tidiness, they both ended their days buried close to each other in St Cuthbert's churchyard in Marton.

Bolckow was very much the money man; Vaughan's skills lay in man management. It only took Bolckow twelve years after coming to England from Mecklenburg to make a £50,000 fortune on the corn market. Vaughan was a man of steel, through and through: he worked his way up in the steel industry in South Wales and Carlisle before coming to Middlesbrough via Losh, Wilson & Bell in Newcastle and Grosmont on the North York Moors. The two met through Joseph Pease.

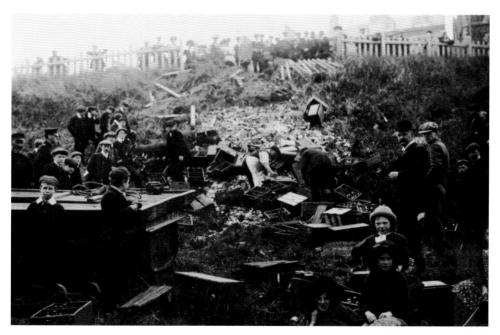

A Gibson and Co. of Emmerson Street 'pop' lorry crashed down the railway embankment and ended up on the line; the attraction is clearly visible.

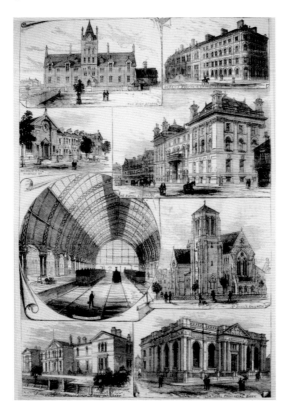

A tour of some of Middlesbrough's finest buildings courtesy of the *Illustrated London News* of 8 October 1881. From left to right clockwise: High School, Queen's Square, the Royal Exchange, Masonic Hall, Marton, St John's church; Railway Terminus, North Riding Infirmary and National Provincial Bank.

Heinrich Wilhelm Ferdinand Bölckow

Henry William Ferdinand Bolckow (1806–1878), was originally called Heinrich Wilhelm Ferdinand Bölckow. His parents were Heinrich Bölckow of Varchow, Western Pomerania, and his wife, Caroline Duscher. Heinrich was born at Sülten in the Duchy of Mecklenburg-Schwerin. At fifteen he went to work in a merchant's office in nearby Rostock; here he met Christian Allhusen, who in 1827 invited him to Newcastle-upon-Tyne to become his business partner in the corn trade. In 1841 Bölckow became a naturalised British subject and took the name Henry Bolckow.

Bolckow anticipated the philanthropic, albeit pragmatic, attitude and work of such enlightened industrialists as Joseph Rowntree, Titus Salt and the Cadburys when he spent £20,000 purchasing and landscaping 70 acres to create a free public park for the people of Middlesbrough. Albert Park was opened by Prince Arthur in 1868, named in memory of the late Prince Albert, a fellow German. In 1869 Bolckow followed this with £6,583 of his own money to build a school in the St Hilda's district. Bolckow clearly understood that a happy, educated workforce was a productive workforce but his generosity and philanthropy went beyond that: he was a genuine friend to Middlesbrough. Another school to benefit was Capt. Cook's Memorial School in Marton while the Mechanics' Institute received donations and books. He set up the Miners' Hospital in Eston and paid two thirds of the cost of the North Riding Hospital, then on Newport Road.

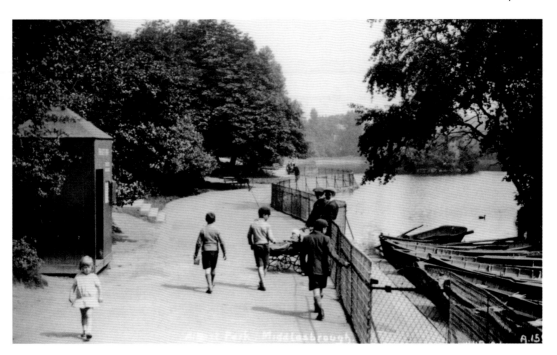

Strolling in Albert Park.

In 1853, the town was granted a charter of incorporation with Bolckow the first mayor of the new municipal corporation; Vaughan followed him two years later. In 1864, Bolckow & Vaughan became a limited liability company with a capital of £2,500,000, and with Bolckow its first chairman.

In 1867 Middlesbrough was granted parliamentary representation and Bolckow stood as Liberal candidate; he was elected unopposed as the town's first Member of Parliament on 16 November 1868 and held the seat until his death ten years later.

In 1877 Bolckow became ill from kidney disease and was taken to Ramsgate to recuperate; he died on 18 June at the Granville Hotel, Ramsgate , aged seventy-one. He is buried at St Cuthbert's church, Marton, close to where John Vaughan had been buried in 1868.

Henry was twice married. In 1841, he married a widow, Miriam Hay, whose sister was married to Vaughan. Miriam died the following year and Henry remarried in 1851; his second wife was Harriet, only daughter of James Farrar of Halifax.

A statue commemorating Henry Bolckow stands in Middlesbrough's Exchange Square, opposite the railway station. As mayor, Bolckow dedicated a granite urn to Capt. James Cook in the grounds of his home at Marton Hall, close to where Cook was born. Apart from owning an impressive art collection, which sold at Sotheby's for a record amount for a one-day sale, Bolckow kept an equally impressive library that included some of Capt. Cook's journals, feared lost until they were discovered on Blocklow's death. The Hall burnt down in 1960, but the urn now resides in Stewart Park, also the home of the Captain Cook Birthplace Museum. Bolckow's mastiff, Lady Marton, is one of the foundation bitches of the modern breed.

John Vaughan, One-time Puddler

John 'Jacky' Vaughan was born in Worcester in 1799 to Welsh parents. Vaughan followed his father into Sir John Guest's Dowlais Iron Works in South Wales where he worked in the scrap mill, graduating from there to become a puddler, then a furnaceman, then a foreman. After Dowlais, he moved to steelworks in Staffordshire, then to Carlisle as factory manager. It was as the works manager for the Losh, Wilson and Bell Iron Works in Walker-on-Tyne that he met Henry Bolckow, corn merchant and aspiring ironmaster...

Vaughan must have been a persuasive advocate because he sold the idea of a substantial investment in the iron industry to Bolcklaw, a man who at the time knew nothing about the commodity or its industry or what he might be letting himself in for.

In 1855 Vaughan was Mayor of Middlesbrough; he was also a Borough Magistrate and a member of the Tees Conservancy Board. His first wife was Eleanor Downing. While in Newcastle Vaughan met his second wife, Eleanor Hay, sister of Miriam Hay, Bolckow's wife. Eleanor died having borne him four children. In 1858 he moved from Cleveland Street to Gunnergate Hall off Tollesby Lane. In retirement he lived near Stokesley at Skutterskelfe Hall. Vaughan died in London on 16 September 1868; he too got his statue in the centre of Middlesbrough.

Getting Out in Middlesbrough

Culturally, there was much to entertain and edify the people of Middlesbrough during the iron revolution: the Orpheus Music Club, and a choral and a philharmonic society; the Carnegie Library; the Cleveland Club; the Mechanics' Institute and the Athenaeum, which became the Literary and Philosophical Society. For many, Saturday afternoon meant Middlesbrough FC. The library was financed by the Scottish-American industrialist and philanthropist Andrew Carnegie and was one of the 3000 Carnegie Libraries he set up in the UK and USA and in countries in what was then the British Empire. The first in the UK was opened in 1883 in his home town of Dunfermline. The generous deal was that Carnegie would build and equip, but only on condition that the local authority matched that cost by providing the land and a budget for operation and maintenance.

The aim of Mechanic's Institutes was to provide a technical education for the working man and for professionals to 'address societal needs by incorporating fundamental scientific thinking and research into engineering solutions'. They transformed science and technology education for the man in the street. The world's first opened in Edinburgh in 1821 as the School of Arts of Edinburgh, later to become Heriot-Watt University. This was followed in 1823 by the Institute in Glasgow which was founded on the site of the institution set up in 1800 by George Birkbeck and the Andersonian University (now known as the University of Strathclyde) offering free lectures on arts, science and technical subjects; it moved to London in 1804, became The London Mechanics' Institute from 1823 and, later, Birkbeck College. Liverpool opened in July 1823 and Manchester (later to become University of Manchester Institute of Science and Technology) in 1824. By 1850, there were over 700 Institutes in

the UK and abroad, many of which developed into libraries, colleges and universities. Mechanic's Institutes provided free lending libraries and also offered lectures, laboratories, and occasionally, as with Glasgow, a museum.

Middlesbrough Religions

From a religious point of view, Middlesbrough was quite cosmopolitan: a synagogue opened in 1874 in Brentnall Street. The Friends' Meeting House was in Dunning Road while a German church was established in Elm Street; the Zion Love Memorial chapel was in Corporation Road. The first Catholic church had been around since 1834, its congregations swelled by the Irish immigrants who arrived in the middle of the century. In the 1851 census Middlesbrough was shown to be second only to Liverpool in the percentage of Irish living here; the Welsh, too, featured prominently.

St Hilda's

We have seen how Pease's town plan for Middlesbrough was symmetrical, with streets radiating from the central market place. That did not last long: the town centre today is very different from the original town. The railway line and the station were to the south from 1877; Middlesbrough's boundaries expanded south of the railway, with the result that commerce and local government moved south with it. In 1899 the old town hall was replaced by the Houses of Parliament lookalike, still to be seen in Corporation Road.

Linthorpe Road

Linthorpe Road was already the main shopping street following the old country route from Linthorpe to Middlesbrough known as Linthorpe Lane. It now forms part of the modern epicentre of the town with Albert Road, Grange Road and Corporation Road all including the university, the Central Library, and the law courts, radio stations, shopping centres, car parks and other shopping streets.

Over the Border

'Over the border', to the north of the railway, Middlesbrough's oldest pub, the Ship Inn in Stockton Street, still stands, as does the old Town Hall. There are some fine Georgian-style houses in Queens Terrace, two of which belonged to neighbours Bolckow & Vaughan.

Middlesbrough in the Second World War

The Luftwaffe's first raid on a UK town of any size and on an industrial target was on 25 May 1940 at Cargo Fleet – South Bank when Dorman Long was bombed. Middlesbrough had 481 alerts during the war with eighty-eight fatalities, 158 seriously injured and 421 with minor injuries.

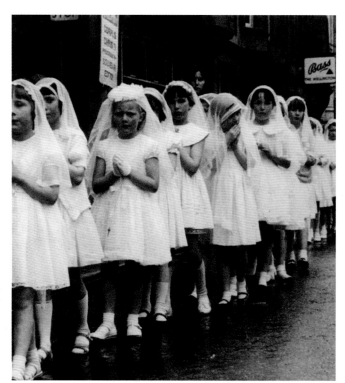

Above: Builders posing for the camera during the construction of St Barnabas' church. The church was opened for services well before it was complete; the opening ceremony took place some four years later in 1897.

Left: 1960 Corpus Christi parade showing children from St Patrick's School and the Convent School. Other participants included Women's Confraternity and Young Christian Workers. 1,000 parishioners waited for the parade to finish the quarter mile route to attend an open-air service.

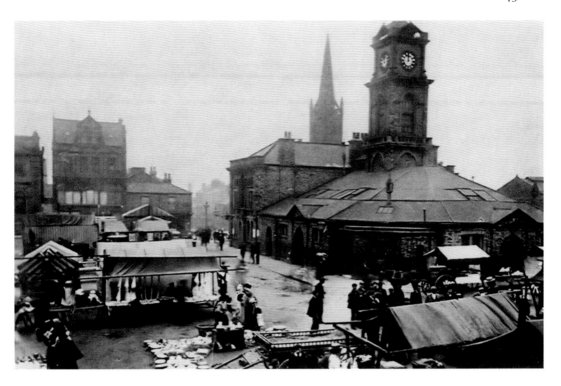

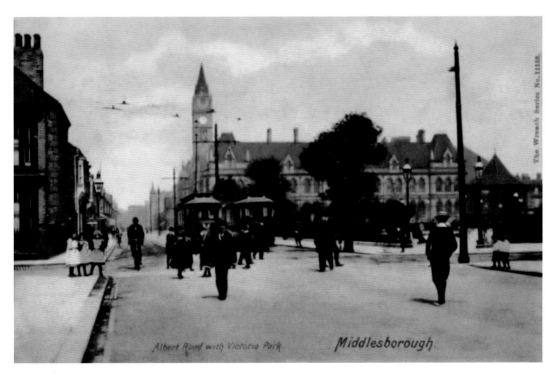

Albert Road and Victoria Park.

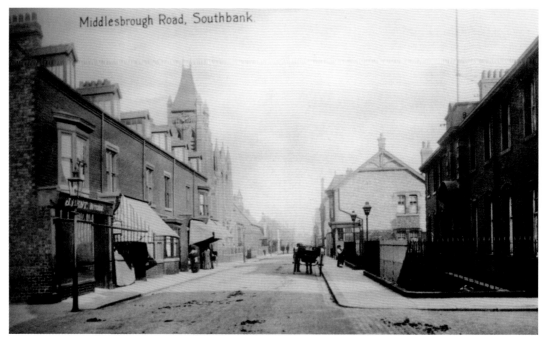

Middlesbrough Road, South Bank.

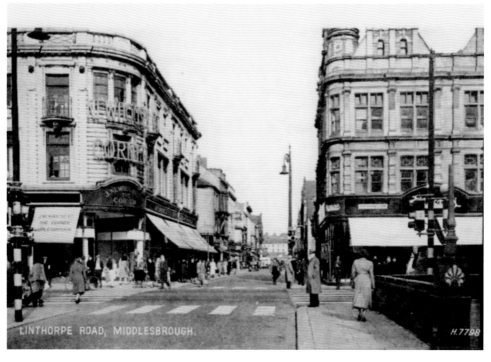

Linthorpe Road.

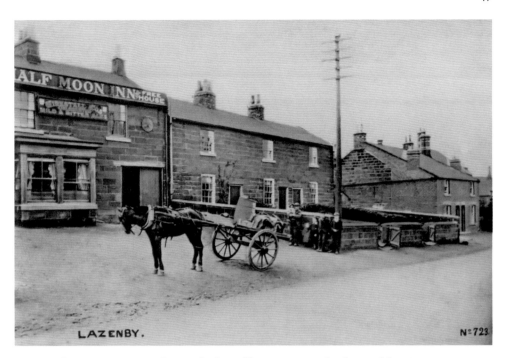

Horse and cart waiting patiently outside the Half Moon at Lazenby during deliveries.

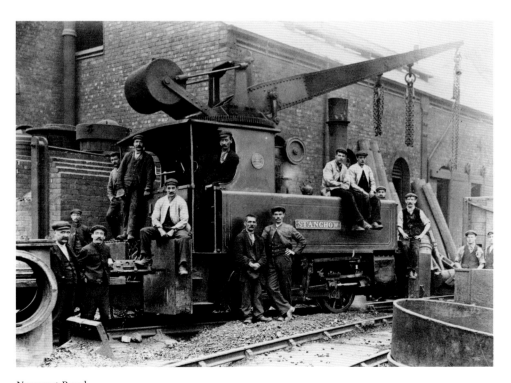

Newport Road.

Middlesbrough was bombed during the nights of Saturday 25 and Sunday 26 July 1942. The German bombers attacked in relays, dropping twenty-eight tons of bombs and incendiaries causing twenty-five fires. Victoria Hall, Co-op Emporium and Eaton's Store were all razed to the ground; the Leeds Hotel was destroyed by a direct hit, causing four fatalities. In all, sixty-eight houses and seventy-six business premises were destroyed, while minor damage was done to 1,000 houses and to 221 business premises; only two industrial premises (presumably the objective of the raid) were damaged. Sixteen people were killed, fifty injured and 200 rendered homeless. Middlesbrough railway station was badly damaged during a daylight raid on 3 August 1942 and a train heading for Newcastle was destroyed – fortunately, there were no passengers on board. The bomb exploded at the front of the engine, penetrating through to the station subway and bringing down the arched roof. During the two days during which the station was out of commission, United Buses took over: in an act of quintessential Britishness, LNER guards assumed control on the buses with their whistles and green flags. *North East Diary 1939–1945* gives a report of the raid:

An attack on Middlesbrough by a single, low flying, Dornier 217 around noon, resulted in eight dead and fifty-eight injured. Of the four 500kg bombs dropped, two demolished most of the town's LNER railway station and damaged the front part of the Middlesbrough to Newcastle express. Machine gunning was also reported.

Unsound Carcasses

Middlesbrough had to learn the hard way about food hygiene, according to Bulmer's *History and Directory of North Yorkshire* for 1890:

For twenty-eight years Middlesbrough was the great mart for vending all measled pork and other flesh of diseased animals totally unfit for food, which was sent from many miles around; but, in 1858, Mr. John Reed was appointed as Inspector of Meat, and his unceasing vigilance during the twenty-nine years which he held the office resulted in the seizure, from time to time, of a great number of unsound carcasses, which, after having been carefully examined and legally condemned, were burnt by him at the gas-house, and the offenders fined; and this precaution had the undoubted effect of frightening other unprincipled people from sending the carcases of their diseased animals for sale... now, no town in England is better supplied with good butchers' meat than the borough of Middlesbrough.

The Floating Hospital

St Luke's Hospital on Marton Road opened in June 1898 with its own fire-fighters, cobblers, laundry, kitchen and bakery. Other hospitals included West Lane (1872) in Acklam Road for infectious diseases such as scarlet fever, typhoid and smallpox. A tuberculosis ward opened in 1912. Other isolation hospitals included the floating hospital at Eston Jetty and Hemlington Hospital. In 1893, there were more than 800 cases of

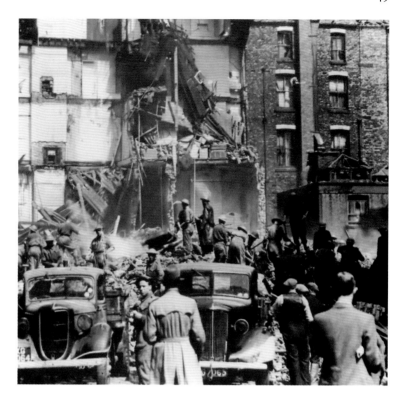

1942 bomb damage.

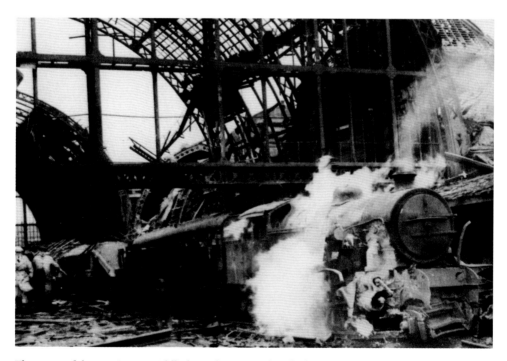

The scene of destruction at Middlesbrough station after the bomb had hit.

scarlet fever, enteric fever and smallpox. The floating hospital came about because the situation locally became so critical that the chairman of the Tees Port Sanitary Authority, Alderman Sadler, mooted the revolutionary idea of a temporary floating hospital on the Tees. It replaced the previous isolation hospital which from 1886 had operated from the brig *Remembrance* – maybe not the most hopeful or reassuring of names. Shipbuilders Head Wrightson won the contract and built a ship that accommodated thirty beds. Called *The Osprey*, it cost £800 and was in service until 1929.

Other Middlesbrough Hospitals

By 1918, Middlesbrough had six hospitals: two voluntary institutions – North Ormesby Hospital (1861) and the North Riding Infirmary (1864) – the Poor Law Infirmary of 1878, which changed its name to Holgate in 1915, and its separate children's hospital and the two municipal hospitals for infectious diseases, one built in West Lane, in 1872, the other at Hemlington, in 1895. During the next twenty years, all of these hospitals were enlarged and upgraded while three new institutions were added – a municipal maternity hospital in 1920, a voluntary bequest general practitioners' hospital in 1926 and a tuberculosis sanatorium between 1932 and 1945. By 1935, Middlesbrough had around 600 general beds, plus some 250 for infectious diseases, including various forms of tuberculosis provision, eighty paediatric beds and fifty for maternity.

Bolckow Vaughan Women's Football Team

Women's football was much more popular in the early twentieth century than it is today – despite a recent resurgence. In 1918, Bolckow Vaughan, in common with other north-east manufacturing firms, ran its own women's football team; many factories had been converted to munitions work during the war. Bolckow Vaughan's Mutionettes team were runners-up in a replayed final tie for the *Tyne Wear & Tees Alfred Wood Munitions Girls Cup*. Unfortunately, they were beaten 5-0 by Blyth Spartans. This was one of the earliest instances in history of women's football. Other clubs in the region included Dorman, Long & Co., Teesside Ladies, Ridley's, Skinningrove, Skinningrove Iron Works, Smith's Docks, Richardson, Westgarth (Hartlepool) and Christopher Brown (West Hartlepool). These were not just casual kick-arounds but highly organised matches played at such venues as Ayresome Park and St James's Park. By 1918 there were more than 900,000 munitionettes producing 80 per cent of the weapons and shells used by the British Army.

Rolando Ugalini: The Goalie from Lucca

Middlesbrough Football Club was an international side even back in the '50s: one of their goalkeepers was Rolando Ugalini from Lucca, Italy. Gates in those days varied between 35,000 and 50,000. The club was formed in 1876, turning professional in 1899 under the name Middlesbrough & Ironopolis Football & Athletic Club. Initially, the club found it hard to settle: their first two years were played at Albert Park but they caused far too

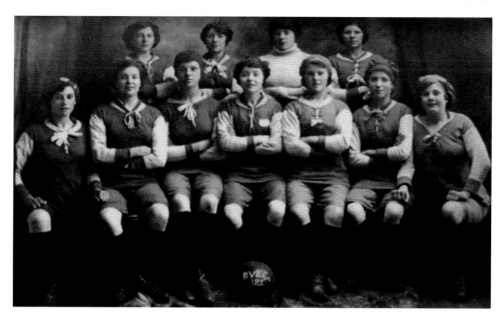

Bolckow Vaughan Women's Football Team.

much damage there and so moved to Breckon Hill. In 1880 they relocated to the Linthorpe Road Ground, home then of Middlesbrough Cricket Club who left for the Breckon Hill field. In 1903, they transferred to Ayresome Park opposite Ironopolis' old ground, the Paradise Ground, where they stayed for the next ninety-two years. In 1905, 'Boro bought Alf Common for £1,000 from rivals Sunderland – a record fee at the time.

The Middlesbrough Meteorite

Not that many places in the world can claim to have been the final resting place of a meteorite. Around 3.30 p.m. on 14 March in 1881 a 4,500-million-years-old meteorite fell from the sky and landed in the town yards away from where some railway workers were hard at work at Pennymans's Siding, near to where St Luke's Hospital was. The British Museum wanted it, but because if fell on their land, the North Eastern Railway considered the meteorite 'lost property', and kept it in Yorkshire. It is now on display in York's Yorkshire Museum.

Middlesbrough and Its Workhouses

The phenomenal rise in population meant that Middlesbrough got its own workhouse in 1875. It was a particularly bad time as unemployment in the area was very high in 1875–76; in 1879, and before the new union workhouse was ready, 300 or so paupers had to be accommodated in workhouses belonging to the neighbouring unions of Darlington, Guisborough, Stokesley and Stockton. Three 'labour test' yards were established, two of which were on the site of the new workhouse site and at the railway

Middlesbrough's Italian goalkeeper on the left in 1951; on the right Wilf Mannion appeals for handball against Chelsea's Harris. Originally published in *Picture Post*, 3 November 1951.

Workers after discovering the meteorite.

station. These yards allowed poor relief to be given in exchange for manual labour — usually stone-breaking. In February, 1878, 382 men were breaking rocks in the three yards. Planning left something to be desired: the union could not dispose of most of the broken stone and by mid-1879 had over £4,000 worth on their hands.

A new workhouse was built in 1877–78 on a 15-acre site between New Cemetery Road (now St Barnabas Road) and Ayresome Green Lane costing £6,750; the first thirteen inmates were admitted in December, 1878. The main building could accommodate up to 726 inmates and by September, 1879, 390 paupers were in residence. The hospital building had 120 beds; the schools building comprised school rooms, day rooms, dormitories, and play yards and had room for 200 or so children aged two to sixteen years. The depression from 1884–87 led to a winter population in the workhouse of around 800, peaking at 813 in December 1886. Relief for single able-bodied men working in the labour yard was 4s a week while men with families received 12s. In 1888 a new yard was built which included workshops, a day room, dormitories, a Test Master's house, a building with twenty-four cells, a corridor with tables for corn-grinding and 7-foot-high walls.

The 1880s witnessed a catalogue of tragic problems: in 1880, a young child was burned to death; in 1882, an 'aged and decrepit female' was found wandering in Stockton having been discharged for no good reason; in 1883 three children were found in a Middlesbrough street by a clergyman after being 'put out from the House' with nowhere to go. In 1887, a child drowned in the plunge bath in the schools block – two inmates were in charge of seventy children in the bath. In 1888 a report on a fever epidemic in the workhouse found that 'not only were the scandalous faults and condition of the drainage of the workhouse a cause of the spread of the malady through the buildings, and the very high fatality of the cases treated there but were the main cause of it'. An independent report revealed that pipes were not connected to main sewers and sewage was running into the foundations of the building.

By around 1903 much rebuilding had taken place. In 1908 the daily labour requirement was to break either a ton of whinstone or 15 hundredweights of slag, or to grind corn, saw wood, or dig the garden for eight hours. Half the payment was in money, half in kind – mainly food. On New Year's Day in 1909, men were given a day off with pay. After 1930, the workhouse became a Public Assistance Institution known as Holgate Institution; 'residents', were now classified into three categories:

Class A - aged inmates of good character and clean habits. They were allowed armchairs, could eat in their day-room rather than in the dining-hall, had an improved diet including 'puddings daily and cake twice weekly for tea', they had superior clothing ('all tweed suits'), and given daily passes, tobacco, and newspapers. Elderly women were spoiled with a quarter pound of boiled sweets a week.

Class B – mainly aged and infirm men. These were allowed forms or upright chairs, had to dine in the dining-hall, had passes for Saturday afternoons and one other day per month, and received tobacco and daily newspapers.

Class C – able-bodied men 'not of good character or clean habits'. These had to sit on forms, always ate in the dining-hall, received a pass once per month, and 'tobacco for special work only'.

1890 Commercial Middlesbrough

The businesses that a town supports reflect, to a large extent, its industries. Middlesbrough is no exception; here is a snapshot of commercial life in the Middlesbrough of 1890, as recorded in *Bulmer's Directory* of 1890.

The Whig MP was Isaac Wilson, Esq., J. P. and D. L. who lived at Nunthorpe Hall, and was a member of the Reform and National Liberal Clubs.

Iron and steel was serviced by nineteen iron brokers; two galvanised corrugated sheet-iron manufacturers and galvanisers; four grease manufacturers; eight iron founders; six iron manufacturers; sixteen iron masters; forty-two iron and steel merchants; fourteen ironmongers; seven steel makers; six tinplate workers; three iron tube makers; five wheelwrights; five whitesmiths and bellhangers;

The river industries were supported by two boat builders and block and mast makers; four boiler makers; two bolt, nut, and rivet makers; twenty ship brokers; seven marine stores; fifty-seven master mariners (including a James Storm); three nautical instrument dealers; one pilot master and sixteen pilots; two sail makers; three shipbuilders; five ship chandlers; thirteen ship owners; nine ship smiths and shipwrights; four steamboat and tug owners; seven stevedores; four wharfingers.

The coal industry was represented by thirty two coal dealers; thirty four (separate) coal merchants; twelve coal owners; five coal exporters.

There were 102 butchers, including two Mr Trotters, one Mr Peacock and one Mr Lamb; five butter and egg dealers; three fish curers; seventeen fishmongers; fifteen fried fish shops; eight game and poultry dealers; three oyster dealers; nine tripe dressers.

Specialist shops and trades included three baby linen dealers; three basket makers; two bed and mattress makers; six Berlin wool repositories; three bicycle makers; three bird dealers and two bird stuffers; sixty-six boot and shoemakers; one boot upper maker; six chimney sweeps and one sweep machinery dealer; two cigar dealers; two cloggers; two curriers and leather sellers; only three electricians; four fent dealers; fourteen hatters; nine herbalists; seventeen hosiers and glovers; two leather merchants; thirteen printers; four sewing machine manufacturers (including Singer's Manufacturing Co at 33½ Corporation Road); two slipper makers; three straw bonnet makers; sixty-one tailors and drapers; three tobacco manufacturers.

Agriculture had twelve blacksmiths and farriers; thirteen cart owners; four cattle dealers; one hide and skin dealer; two coopers; thirty-eight dairymen and cowkeepers; five hay and straw dealers; four saddlers and harness makers; two vets.

Other specialist trades included one cork cutter; one cork merchant; four cutlers; eight oil, grease, and tallow merchants; two tallow chandlers; one tallow refiner;

There were two artists: Miss Ettie Knot, and Thomas Smiles. Turkish baths were in Grange Road; there was one bone setter; six bookbinders; twelve booksellers; two dancing masters; four emigration agents; seventy-three pubs; five music and musical instrument dealers; two newspapers: the Liberal *North Eastern Daily and Weekly Gazette* and the *Northern Review*. Ten other papers had offices here representing publications from

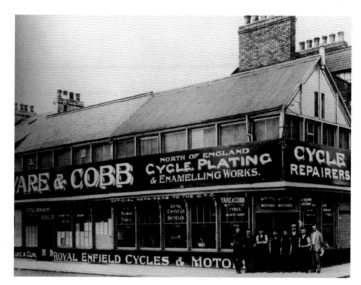

The cycle business on the corner of Russell Street and Bright Street – originally owned by G. M. Young.

Newcastle to York; sixteen pawnbrokers; one language teacher; fourteen music teachers; four publishers; four registry offices for servants; eight temperance bars and hotels.

The following countries had consulates in Middlesbrough: Belgium; Denmark; France; Italy; Spain; Sweden and Norway; The German Empire; The Netherlands; United States of America.

Show Business Middlesbrough

In the late nineteenth and early twentieth centuries Middlesbrough was well served with theatres. They included the Hexagon Theatre, Little Theatre/Middlesbrough Theatre in the Avenue, opened in 1957 by Sir John Gielgud, Theatre Royal in Albert Street opened in 1866 and then in Corporation Road from 1900, Oxford Palace of Varieties, opened in 1867 – it was bombed in 1941 and later demolished, Empire Theatre in Corporation Road (formerly the Empire Theatre of Varieties, opened in 1899 with a variety show of seventeen acts including Lily Langtry), Hippodrome in Wilson Street (opened in 1908), Grand Opera House/ Gaumont Cinema in Linthorpe Road and Southfield Road (opened in 1903) and was the Gaumont cinema in the 1920s–29, February 1964 saw the last film, *The Longest Day; Prince of Wales Theatre* in Cannon street (opened in 1875), The Pavilion, Esk Street, North Ormesby – formerly The Grand Electric Theatre/ Pavilion Picture Palace/ Playbarn (opened in 1911), Price's Spanish Circo (opened in 1866), The Ship Inn Music Hall, also opened in 1866.

Lady Florence Bell

Lady Florence Bell (wife of ironfounder Sir Hugh Bell) is the author of *At The Works* – a perceptive social study of Middlesbrough as a manufacturing town, published in 1907. Florence Bell was the stepmother of Gertrude Bell and the family lived in Coatham. In

This fine-looking carriage is parked at the back of the Temperance Hall in Park Street at the end of the nineteenth century. The poster promotes Sequah, a well-known quack of the day who dressed as a Red Indian. The hall opened in 1877 and could seat 2,000. It later became the Marlborough cinema, renamed the Metro in 1959.

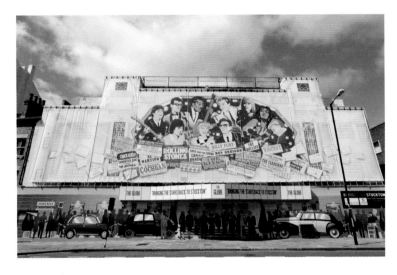

The Globe undergoing a facelift in 2015.

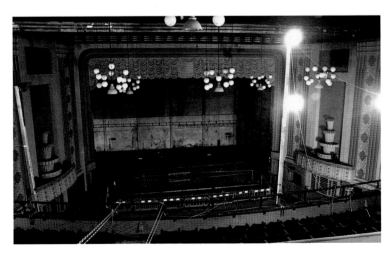

The sumptuous interior of the Globe, awaiting scenery.

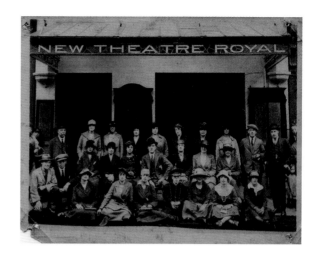

One of the casts at the Theatre Royal with the proprietor John Charles Imeson on the back row far left with the bowler hat. (Photo courtesy of Maurice Friedman, British Music Hall Society.)

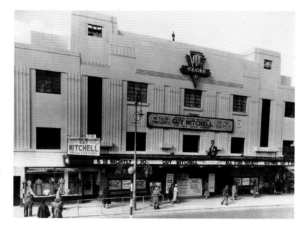

Guy Mitchell featuring at the Globe in the late '50s. Photo courtesy of Barry Jones, Archivist and Historian for the Globe Theatre.

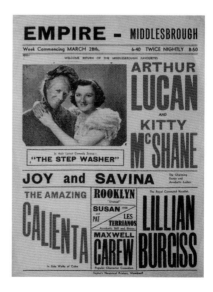

A 1940s programme for the *Middlesbrough Empire*. 'Step-washing' was important in working-class areas – a visible symbol of respectability and cleanliness inside the door.

over one third of the houses visited, the wife did not know what their husbands' wages were. However, while the man of the family was the undisputed breadwinner, many well run families owed everything to the household and financial management that was exclusively the domain of the wife and mother. It is she who allocates the contents of the pay packet and runs the house.

At the Works: A Study of a Manufacturing Town

We are extremely fortunate to have this invaluable, fascinating social research which Lady Bell conducted in Middlesbrough over thirty years. She and her fellow researchers (all women) visited over 1,000 families connected the steel industry from 1880 or so to 1906 and produced a fascinating and revealing work of social history. The aim, successfully achieved, was to describe the daily lives of the workmen engaged in the iron trade, living in crowded conditions in small, cheap houses in the 'mean streets of Middlesbrough' with their families, which could just as likely include up to twelve children rather than the two or three the houses were built for. Although Bell paints a bleak, realistic picture, she knows that there can be hope:

> There is nothing to appeal to a sense of art and beauty... But yet imagination can be stirred – must be stirred – by the Titanic industry with which it deals, by the hardy, strenuous life of the north, the seething vitality of enterprise with which the town began... towards the centre and the north, serried together in and out of the better quarters, there are hundreds of the little streets we have described, in which lives a struggling, striving, crowded population of workmen and their families : some of them, as will be shown, prospering, anchored, tolerably secure, some in poverty and want, the great majority on the borderland between the two.

Her description of the industrial banks of the Tees reveals a squalid landscape:

> The banks on either side are clad in black and grey. Their aspect from the deck of the ferry-boat is stern, mysterious, forbidding : hoardings, poles, chimneys, scaffoldings, cranes, dredging-machines, sheds. The north shore, the Durham side, is even more desolate than the other, since it has left the town behind, and the furnaces and chimneys of the works are interspersed with great black wastes, black roads, gaunt wooden palings, blocks of cottages, railway lines crossing the roads and suggesting the ever-present danger, and the ever-necessary vigilance required in the walk from the boat. A dusty, wild, wide space on which the road abuts, flanked by the row of the great furnaces, a space in which engines are going to and fro, more lines to cross, more dangers to avoid; a wind-swept expanse, near to which lie a few straggling rows of cottages. A colony of workmen live here.

But it is surely no more than would be expected of an unremittingly industrial landscape at the time. Bell herself confesses that many of the inhabitants love living in these circumstances, driven more by the sense of community they inspire than by natural beauty.

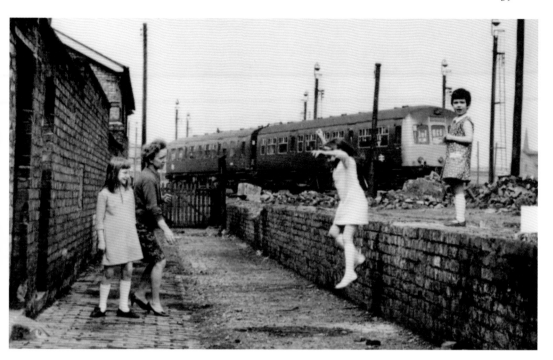

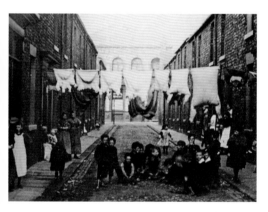

Top: The hazards were still there in the 1960s as Mrs Harrington tries to keep her children off the line. (Photo courtesy and © of the *Northern Echo*.)

Above: Another view of the urban poverty in the town, in Mineral Street with the results of 'possing and scrubbing' for all to see as there was no room in the yard for the washing line. The Oxford Palace of Varieties is in the background.

Right: Life in the shadow of a looming gasholder in 1954.

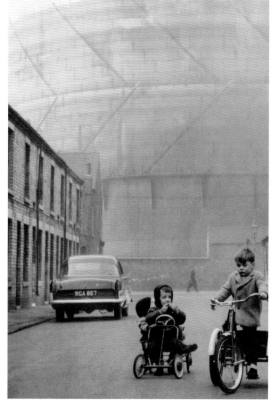

Details on such topics as diet, food budgets and clothing are meticulously recorded. Here are Bell's scrupulous findings on footwear, the expense and the social and health ramifications:

> The question of boots, both for children and grown-up people, is with the badly-off a constant difficulty, and one of the most serious that they have to face; and the miserable foot-gear of the women and children especially as the men are obliged to have more or less good boots to go to work in is a constant source of discomfort and of injury to health. One reason why so many of the poor women go about with skirts which drag about in the mud is that they do not want to display what they have on their feet by holding their skirts up. A working-girl said on one occasion that she thought the mark of a 'real lady' was that she wore a short skirt and neat boots, this last representing to the working-girl almost the unattainable. Boiled-boot shops are still met with. 'Boiled' boots are old boots begged, found in the street, etc., picked up, patched, polished, and sold at a low price. There are various old-clothes shops, market stalls, hawkers' barrows, at which men's suits as well as women's clothes can be bought for a trifling sum.

Industrial accidents were legion and common; this is a catalogue of the more serious accidents over a period of three years:

> One man had had his legs scalded from hot steam escaping from a boiler ; another had his finger crushed by a piece of iron falling upon it; eyes had been injured by explosions; arms had been amputated in consequence of accidents to them; one man had his foot crushed by a loaded barrow falling on it; one twisted his thigh while he was charging the furnace. A workman injured when employed in or about a works on his master's business is now entitled to be paid after the first week not less than 50 per cent, of the average earnings for the previous twelve months, up to £1 per week. If the incapacity to work lasts more than a fortnight, payment is to date from the day of accident. The most terrible of all accidents occurred, in which two men fell into one of the blast-furnaces... where the temperature is about 3,000°F.

Perhaps the most intriguing chapter is that covering wives and daughters; here we find fascinating details on housekeeping, marriage and raising children. Out of 800 houses in which the number of children was inquired into fifty-eight women had had no children; ninety-seven had families of nine and upwards; 275 had lost one or more children; one woman had six children in eight years; one woman had had seventeen children, and twelve had died; another had fourteen children , of whom eight had died. One woman had had ten still-born children, in addition to which four more were born alive; another woman seven who were all still-born.

Child mortality sometimes brought with it unexpected, to our ears, shocking, reactions:

> One woman whose child had just died said in reply to condolence that 'it would not have mattered so much in another week, as by then the insurance would have come in.' Another spoke almost flippantly about all her children dying, and said, 'It is better they

died, for I had them all insured.'

This, perhaps, can hardly be wondered at, when one considers what the constant physical strain must be, in the case of a large family, merely to keep the children alive. To the weak and ailing mother the child is looked upon often as more of a trouble than a joy, and if insured its death is a positive benefit instead of a misfortune. It is allowed to die, therefore, without making much effort to keep it.

Bell's statistics tell us that infant mortality in Middlesbrough was exceptionally high. In 1904, out of 2,072 deaths in the twelve months among the whole population, 650 were those of children under one year, and this does not include the many deaths among the children who were just a little older. For one month in 1905 the deathrate was higher than that of any town in the UK.

Pain relief of any kind in childbirth was rare:

The women, except in exceptional cases, where there is some complication, do not have chloroform for their confinements; they have therefore no mitigation of their sufferings. It must be said, however, that they do not as a rule wish to have it. They have a great dread of becoming unconscious ; they think they will die under it. It is illegal to administer it without the consent, sometimes refused, of the husband.

The stereotypical nosey housewife appears to have been alive and well, anxious for anything to relieve the monotony of an often humdrum life:

They will all rush to their doors to see any incident that may be attracting attention in the street – a quarrel, or, still better, a fight; indeed, without anything so exciting, the mere passage of a stranger walking down the street will bring every one of them out on to the doorstep to look after him, often to the great discomfiture of the unwary passer-by. A wedding or a funeral they will, of course, go any distance to see, and even the departure on police-court days of the prisoners going by train to the county gaol is a great centre of interest and excitement, and men, women, and children stand in the station-yard round the prison van.

Another generalisation is borne out:

Many of the women exhibit a sort of dogged acceptance of the matrimonial relation with its rough as well as its smooth side (domestic violence); and it is small wonder that in many cases the woman ... without any attempt at conciliation, should make undue use of her chief weapon, her tongue. It must be conceded that most of the women have not the slightest idea of self-control, of not saying the thing that comes into their head, either to their husbands or to one another.

Sir Thomas Hugh Bell and His Private Platform

Sir Thomas Hugh Bell was a director of Bell's Steel Works and a director of the North Eastern Railway; he had a private platform on the Middlesbrough–Redcar line at the bottom of his garden at Red Barns in Coatham.

He was a beneficent employer and the following story, recorded in Georgina Howell's biography of his daughter, Gertrude Bell, illustrates the regard in which he was held:

> His [other] daughter, Lady Richmond, recalled saying goodbye to her father at King's Cross. He stayed with her on the platform to chat until the train left. When the train did not leave on time they went on talking, until at last a guard came up to them and said "If you would like to finish your conversation, Sir Hugh, we will then be ready to depart." He was no ordinary capitalist and mill owner, but made sure his workers were well paid and cared for.

Middlesbrough's Native American

Moses Carpenter, a Native American Indian, is buried in Linthorpe Cemetery. Carpenter was of the Mohawk tribe, born in Ontario in 1854; his real name was Ska-Run-Ya-Te. He came to Middlesbrough in 1889 as a member of a travelling show but died of fever.

Chris Rea was born in Middlesbrough, the son of ice-cream maker Camillo Rea who, together with his brother Gaetano, had an ice-cream factory and ran over twenty cafés locally. Chris Rea admits that many of his songs were 'born out of Middlesbrough'. One of the most famous is 'Stainsby Girls', written for his wife Joan, who had attended Stainsby Secondary Modern School before it was, renamed Acklam Grange Secondary School. 'Steel River' is of course a paean to the River Tees which exposes Rea's feelings about the industrial decline of Middlesbrough.

Paul Rodgers (Free, Bad Company and Queen) played bass and sang vocals in local band The Roadrunners before Free.

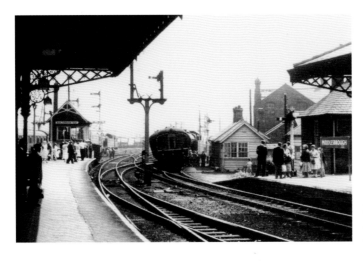

Derailment at Middlesbrough station 8 August 1957.

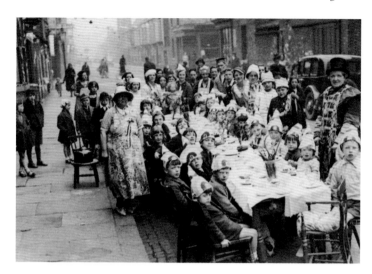

Gloucester Street holding what looks like a wonderful party to celebrate the coronation of King George VI and Queen Elizabeth in 1937.

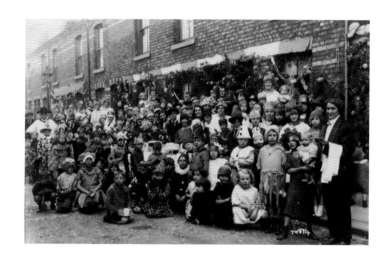

Another grand party – this time for the 1925 carnival.

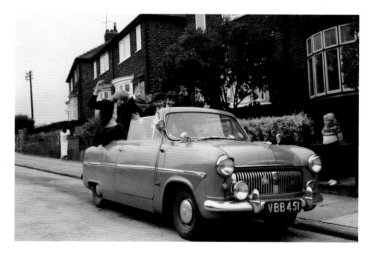

Paul Rodgers here on the right with the other Road Runners in 1965 on the back of an iconic 1954 Ford Consul convertible. (Photo courtesy of Colin Bradley, formerly of the Road Runners.) It was taken outside Joe Bradley's home in Brentford Road in Norton. The Road Runners are , left to right, Dave Usher, Colin Bradley, Micky Moody and Paul Rodgers. The little girl in the gateway is Joe's niece Sharon Jacques (now Sharon Stewart).

Middlesbrough had a vibrant pop and rock scene in the
1960s. Here are a few of the bands that were on the local
circuit: Aquarius; The Electric Plums frommHartlepool; The
Freelanders *(see left)*, and the Road Runners.

The Temenos (110 m long and 50 m
high costing £2.7 million) next door
to the Middlesbrough FC Riverside
Stadium is the first of the Tees Valley
Giants to be completed: a £15 million
series of five art installations
by sculptor Anish Kapoor and
structural designer Cecil Balmond
for the towns of Darlington,
Hartlepool, Middlesbrough, Redcar
and Stockton. Launched in 2008,
if completed it will be world's
biggest public art project. Temenos
was presented to the people of
Middlesbrough on June 10, 2001. The name 'Temenos' comes from the Ancient Greek (τέμενος τέμνω,
temno, to cut), now a term for a piece of land that is cut off or designated for a purpose.

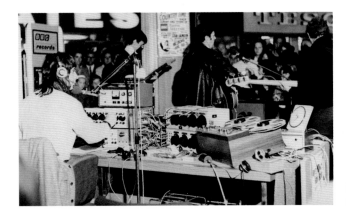

Stan Laundon is the DJ spinning
the discs in a live broadcast from
the Cleveland Centre.

Stockton-on-Tees

Population

The censuses clearly show the effect that industry had on the town's population, from 1871 in particular: population in 1801 was 4009; in 1811, 4229; in 1821, 5006; in 1831, 7763; in 1841, 9825; in 1851, 10,172; in 1861, 13,357; in 1871 it doubled to 27,738; in 1881, 41,015; and in 1891, 49,659.

Shipbuilding

The source of the River Tees is on Crossfell some 68 miles from the Tees estuary; Stockton has been of commercial significance since the thirteenth century, when it filled the need for a crossing point on the trade route between Durham and York. Yarm was initially the

The photo shows Miss Pease, daughter of the railway entrepreneur with her donkey in Stockton.

main port where vessels of up to sixty-five tons could be accommodated, comfortably making the 23 mile voyage to the sea.

Shipbuilding was initially Stockton's forte; it started in the fifteenth century and reached a peak in the seventeenth and eighteenth centuries. In 1470 a wooden ship was commissioned for the Bishop of Durham, using thirty-two stones of iron fashioned into nails at six-and-a-half pennies per stone. Between 1790 and 1805 a Thomas Haw was building ships which saw action in the Napoleonic wars. Three shipping companies were formed between 1822 and 1835: by then 272 ships with a combined tonnage of 51,000 were registered at Stockton, exporting coal mainly; none survived the impending rise of Middlesbrough. The first iron ship turned out here was a screw steamer, the *Advance,* built at South Stockton in 1854 by the Iron Shipbuilding Co., later the aptly named Richardson, Duck and Co; by 1865 they had launched eighty vessels, fifty of which were steamers. At the same time, Pearse, Lockwood & Co. in Ropner's Yard launched sixty-four including thirty-four steamers. The first steel ship was *Little Lucy* built in 1858. Pearse launched their largest steamer, the 377-foot *Talpore* in 1860 – a troop ship which was dismantled and reassembled in India where it saw action on the River Indus. It was the world's largest river steamer at the time. Ships' boilers were much in demand, leading Fossick's to move into marine engineering from 1853.

Rope, Bricks, Cotton, Sugar and Pots

The shipbuilding acted as a magnet for smaller industries such as brick, sailcloth and rope making which is remembered today in local names such as Ropery Street. Just how important rope-making was to the town is underlined by the fact that, in 1825, 1,178 tons of hemp was landed at Stockton. Cotton was important too: a cotton mill was established in 1839 to produce this while the Stockton Sugar Refinery had set up at `Sugar House Open' – the only sugar refinery between Hull and Newcastle.

There was thriving brick-making in Stockton too – bricks were much in demand as towns continued to spring up in the region and with them the urgent need for houses and other community buildings. The Portrack Iron Works opened in 1806 under Brown and Gundry; Stockton Iron Works had been opened in 1770 by John Jackson in West Row; Fosdick and Hackworth started Blair's engine works in 1839 producing locomotives and stationery engines. Tees Glass Works opened their bottle factory in 1839.

The clay used for the bricks also found a market in the hugely important local pottery industry: 1825 saw William Smith open his Stafford Pottery at South Stockton (Thornaby), a new town and in 1860 by his brother James opened a pottery factory called the North Shore Pottery. Others included the Ainsworth's white and printed ware pottery of North Stockton and the Hardwoods Norton Pottery specialising in `Sunderland Ware'. Other 'Owners of the Thornaby Estate' (Smith's consortium) enterprises included the short-lived Thornaby Cotton Mill and the successful Thornaby Iron Works.

Stockton then was the principal port for County Durham, Yorkshire's North Riding and even Westmorland, mainly exporting rope, agricultural produce and lead from the Yorkshire Dales, trading extensively with the Baltic states. The low-level Victoria Bridge built at Stockton in 1770 isolated Yarm.

Coal Exports

Coal became the prime commodity in the Tees Valley; the Tees Navigation Co. held its first meeting in 1808. More good economic news followed in 1825 when the world-changing Stockton and Darlington Railway was opened. The price of coal at Stockton dropped from 18*s* to 8*s* 6*d* per ton and allowed coal to be shipped expediently from the pits of southwest Durham to Pease's staiths at Stockton: coal was being exported from Stockton within four months. Before the railway received its locomotives to run on the line, contractors fixed flanges to the wheels of their carts and coaches and used it as a road. The first ship to leave the Tees with a cargo of coal was the *Adamant* towed by the steam tug *Albion*. Two years later there were five staiths on the Tees below the site of what had once been Stockton Castle.

Stockton, however, could not be complacent, and a number of projects were completed to make it more viable and attractive as a port. In 1810 The Mandale Cut was opened, constructed by the Tees Navigation Co. It cut off one of the Tees meanders, reducing the distance from the Tees Estuary to Stockton by more than 2 miles. Soon after, a second cut, the Portrack Cut, further reduced the distance between Stockton and Newport by three quarters of a mile. Portrack was a response to the ominous growth of Middlesbrough as a port. In the event, the increasing size of ships and the 1827 decision to extend the railway direct to Middlesbrough and by-passing Stockton sounded the death knell for the town. Things were moving fast at Middlesbrough: the first coal staiths at Middlesbrough were built to the west of the 20-acre site on which Middlesbrough would soon mushroom. In December 1830 the *Sunniside* sailed from Port Darlington with the first cargo of Durham coal from Middlesbrough.

A nineteenth-century commentator floridly sums up Stockton's sad demise:

> Vessels now anchor at Middleburgh snug and comfortable, which before strove to mount the river and reach Stockton after overcoming the sad surf tossed over the bar by the easterly gales; so that Stockton as a maritime place has become insignificant.

Stockton Steel

By 1867 there were three blast furnaces, 144 puddling furnaces and six finishing mills in action in Stockton. The companies were Stockton Rail Mill Co.; The Malleable Iron Co., Holdsworth & Co. and the West Stockton Iron Co. They were later joined by Pickerings who manufactured lifting gear, Bowesfield Iron & Steel Co. and Lustrum Iron Works among others. There were more in Eaglescliffe and Thornaby.

Social History of Stockton

The terrible 1832 cholera outbreak killed 126 people died; a further twenty died seventeen years later in the 1849 outbreak. Gas lit the town from 1822. Preston Hall was built in 1825 and a hospital in 1862. 1877 saw the opening of a public library.

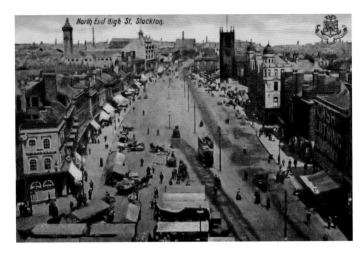

The High Street in 1905 with the equivalent to a Pound Shop on the right.

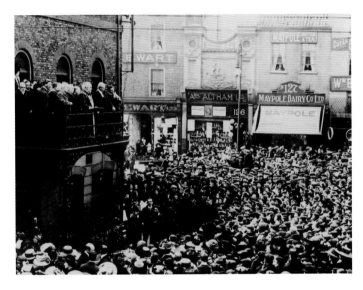

A busy scene at the town hall.

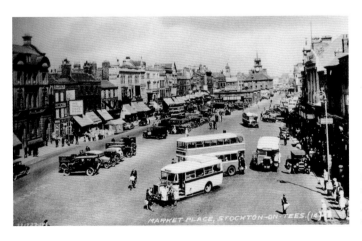

Stockton High Street in the 1930s with Barclays Bank the large building on the left.

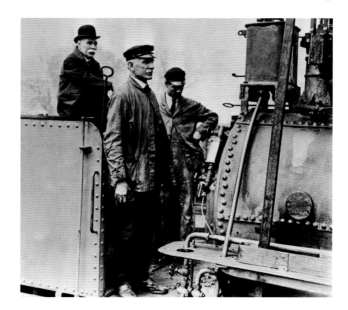

The Hetton Loco in 1925 at the centenary celebrations for the opening of the Stockton and Darlington Railway. The current inspector for the railway, Robert Henry Layton, is on the footplate with the driver and fireman.

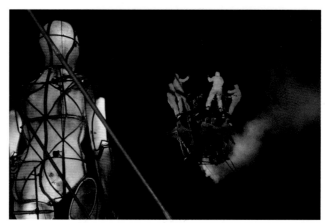

A 2012 display by La Fura dels Baus, which in Catalan means 'The ferret from Els Baus'. Many of the participants were disabled. A female amputee appeared from 'an egg' suspended from a crane and ended up in the palm of the giant man (photo courtesy of Tim Hardy).

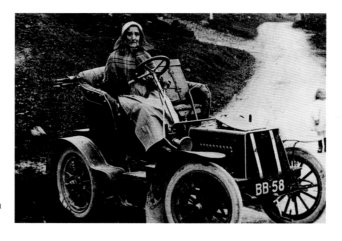

A somewhat unhappy-looking lady, to say the least, at the wheel of a 7 horsepower 'Little Star' at Low Row. The car was registered in Newcastle to Alfred John Nathan Smithson of Stockton – an inveterate car collector who had owned over a hundred by 1968.

Steam trams ran from 1881 replaced in 1897 by electric trams. Ropner Park opened in 1883 and Victoria Bridge was built in 1883.

John Walker Strikes a Light – The Man of the Match

A light came on in Stockton in 1827 when local chemist John Walker invented the friction match in his shop at No. 59 High Street. Walker was born in Stockton in 1781 and was apprenticed to Watson Alcock, the town's principal surgeon. Walker, however, could not stomach the surgery and changed to chemistry. After studying at Durham and York, he returned to Stockton and set up as a chemist and druggist at No. 59 High Street around 1818. The discovery of the match was all rather serendipitous: Walker had been routinely selling concoctions of combustible materials in powder form to smokers and to a gunsmith. In 1826 he was experimenting with these combustibles when, by chance, he scraped the mixing stick against his hearth – the stick caught fire. Samples were distributed locally while Walker perfected his invention: sulphur, tipped with a mixture of sulphide of antimony, chlorate of potash, and gum, on the end of a stick, were sold as friction matches and supplied with a piece of folded sandpaper as the scraping agent. Price was 1s plus 2d extra for the tin containing fifty of the matches; the sandpaper was free. He called the matches 'Congreves' in homage to the rocket pioneer, Sir William Congreve. His first sale and the first customer to strike a light was a Mr Hixon, a solicitor. His daybook initially described the phenomenon as 'Sulphurata Hyper-Oxygenata Fric' which, no doubt for sound marketing reasons, he renamed as `Friction Lights'. His first matches were made of paste board, later replaced with 3-inch wood splints cut by elderly people hired by the chemist. In 1830 an intrigued Michael Faraday came to visit urging Walker to apply for a patent. The reasonably well-off Walker did nothing and inevitably a man called Samuel Johnson took out a patent for 'Friction Matches', branding the matches as 'Lucifers'. The devil, as ever, is in the detail... Walker died in 1859 aged seventy-eight and is buried in St Mary's church in Norton.

Thomas Sheraton and Fashionable Furniture

Thomas Sheraton, famous furniture maker, was born in the town in 1751 where he served his time before moving to London. Sheraton achieved no fame during his lifetime and died in poverty. A pub on Bridge Road bears his name. He authored a number of bibles for furniture designers: in 1791 came the influential four-volume *The Cabinet Maker's and Upholsterer's Drawing Book*. In 1803 he released the cutting edge *Cabinet Dictionary'* a definitive rule book on the techniques of cabinet and chair making and in 1805 he published the first volume of *Cabinet Maker, Upholsterer and General Artist's Encyclopaedia*. Sheraton himself never made any of the pieces from his books and no surviving pieces of furniture can be credited to him directly. So, a 'Sheraton' always denotes the design and not the maker.

The Bell that Never Tolled

Westminster's Big Ben's first bell was cast by John Warner & Sons in Norton in 1856; sadly it was damaged during testing and was never replaced by the company.

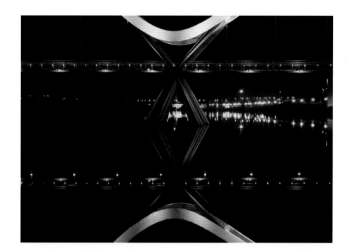

Infinity Bridge illuminated
beautifully, photographed by
Stan Laundon.

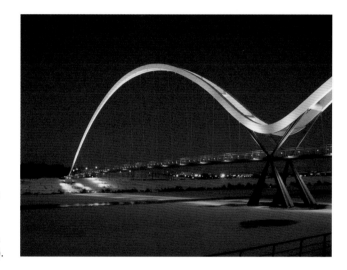

And in the snow over a frozen
Tees in 2010. The coloured
lights were to celebrate the
first anniversary of the bridge
(photo courtesy of Tim Hardy).

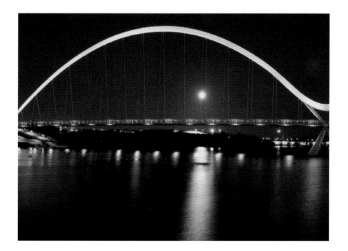

More Infinity Bridge
illuminations from the camera
of Stan Laundon.

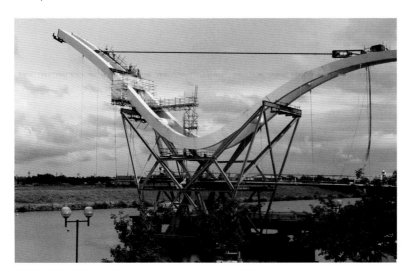

Infinity Bridge under construction (photo courtesy of Tim Hardy.)

What characterises the troupe, La Fura dels Baus, is its use of unconventional venues, music, movement, application of natural and industrial materials, including new technologies and the active audience participation (photo courtesy of Tim Hardy.)

Norton Green in 2010 snow (photo courtesy of Tim Hardy).

Yarm

Yarm, the Early Years

The name Yarm comes from the Old Norse *yarum* meaning fishing pools, or from the Old English *gearum* with the same meaning. Yarm is mentioned in Domesday, as a chapelry in the parish of Kirklevington. Dominican Friars – Black Friars or Friar Preachers – settled in Yarm around 1286 keeping a friarage and a hospital until 1583; Friarage and Spital Bank bear testimony to this. The 1890 edition of *Bulmer's* describes Yarm's ancestry as follows:

> At the time of the Norman Conquest, an Englishman, named Hawart, had three carucates of land here, and land for three ploughs; but he was shortly afterwards ousted from his little domain, and this lordship ... was given by the Conqueror to Robert de Brus, ancestor of the Scottish kings of that name. Later (temp. Henry III.), it came by marriage into the possession of Marmaduke Thwenge, Lord of Kilton in Cleveland, from whom it passed to the Meinells of Whorlton Castle, and their descendants, the D'Arcy, and the Conyers families.

The first known bridge spanning the Tees at Yarm was built in around AD 1200. In 1400 Walter Skirlaw, Bishop of Durham, built a stone bridge to replace it. It was, of course, a toll bridge, which closed between midnight on Saturday until midnight on Sunday. Consequently, coal carts lined up on the Yarm side on Sunday evenings ready to rush across the bridge at midnight to collect loads of coal from the Durham mines. A one-arch

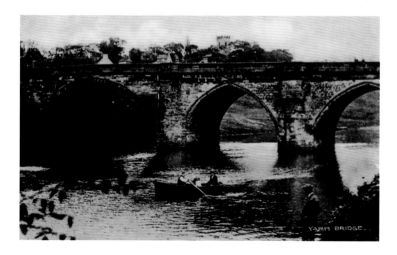

The 1400 Yarm road bridge in the 1920s.

iron replacement was built in 1805, but it came crashing down within a year, just before it opened to the public. At the earlier celebration for the bridge's opening, the Mayor of Stockton must have regretted what he wished for – his speech included the phrase 'May the almighty protect this undertaking, and may this bridge stand the test of time'. The old bridge had, luckily, not been demolished and was repaired and widened; it is still in use today. Ord, in his *History of Cleveland*, describes 'a monument of the liberality and skill of its founder, the good Bishop Skirlaw'.

Yarm the Port

As we have seen, Yarm was the main port on the Tees until increased tonnage, shallow waters and unfavourable proximity to the sea numbered its days in favour of Stockton and then Middlesbrough. The 15-mile route from Yarm to the sea was long and challenging, with journeys taking up to four tides and vessels often running aground.

Industries and the Railway

Yarm supported a number of industries and trades: ropemakers, brewers, tanners, nailers, millers, clockmakers and shipbuilders all made their livings here. The town had a starring role in the birth of the railway in Britain. On 12 February 1821, a meeting was held at the George & Dragon Inn successfully calling for a Bill to grant permission to build the Stockton & Darlington Railway.

Industries were mainly corn, but while this had declined by 1890 the manufacture of flour was still very important made in a steam flour mill; there was also a tannery, Tees Paper Mills from 1832, and Cecil Wren and Co.'s vinegar brewery. Every Monday morning women of the town would go over to the paper mill to fetch two buckets of boiling water for a 'ha'penny' to do their washing. The road past the mill was known as 'Paper Mill Bank' then. Apart from brewing malt vinegar, Wren's manufactured condiments, pickles and sauces.

The grand 2,280 feet (nearly half a mile) long railway viaduct was built between 1849 and 1851 for the Leeds Northern Railway. It took seven million bricks and has forty-three

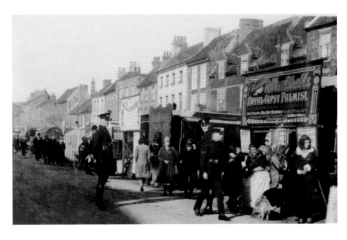

Yarm Fair with the police never far away.

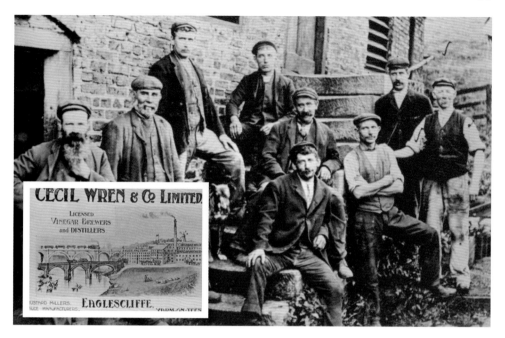

Tannery Workers at the end of the nineteenth century.
Advertising card for Wren's vinegar brewery (*inset*).

arches – the two spanning the river are skewed. It was built to extend the Leeds and
Thirsk railway from Northallerton to Stockton and Hartlepool. In 1855, three years
after the opening, a train overshot the platform on a very stormy and dark night: an
unsuspecting passenger got out of his carriage and stepped over the parapet, falling the
74 feet to his death. The inquest recommended that 'some fencing be erected'.

Yarm Fair

An annual fair, the only one of many to survive, is held in High Street in the third week
in October, starting on the Tuesday evening, lasting until Saturday night. It originally
traded in cheese, sheep and cattle, but is now mainly a funfair. It was the biggest fair in
the north-east for cheese with 500 tons or so arriving in 1900 in over 400 horse-driven
carts. Travellers paraded on horses up and down the High Street on the Saturday ('riding
the Fair'). Tradition requires them to wait outside the town until 6.00 p.m. on the Tuesday
when they are allowed to cross the bridge over the Tees into the town.

Coaching

In the middle of the High Street is the Dutch-style Town Hall built in 1710 by Viscount
Fauconberg, Lord of the Manor of Yarm. It replaced the old tollbooth. Yarm was a vital
coaching stop on the north-south route to and from London and Edinburgh. To service
this traffic there were many hostelries: in 1890 *Bulmer's Directory* listed twelve inns

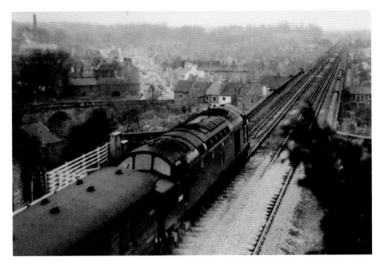

An unusual view of the viaduct.

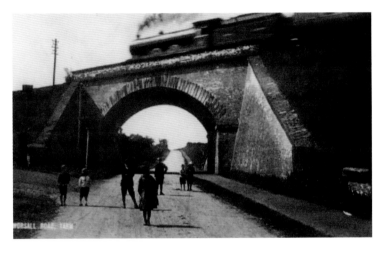

Worsall Road.

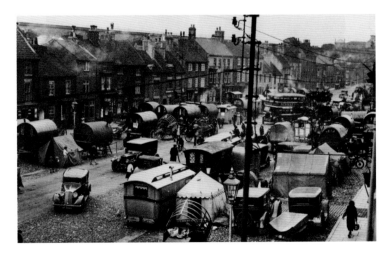

The cheese at the fair.

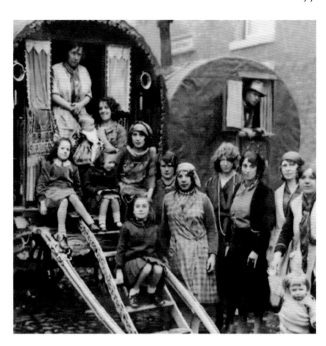

Happy gipsy families at Yarm
Fair in 1931.

in Yarm – Black Bull, Cross Keys, Crown Inn, Fleece, George and Dragon, Green Tree, Ketton Ox, Lord Nelson, Red Lion, Three Tuns, Tom Brown, and Union and the Cross Keys next to the Leven Bridge. A number survive, including the `Ketton Ox', named after the famous ox bred near Darlington and noted for its cockfighting; and the `George and Dragon' where the 1820 meeting was held and the decision was made to build the Stockton & Darlington Railway.

Flooding

'Inundation', or flooding, has been a constant problem in Yarm, situated as it is on flat ground within the confines of a tight bend of the River Tees. The most notable were the floods of 1753, 1771 and 1783; a marker on the Town Hall indicates the height of the 1771 flood on 17 September as being 7 feet above ground. A man from Redmarshall describes the 1753 flood in a letter:

> About one o' clock in the morning it came into Yarm, throwing down all the garden and orchard walls, and forcing its way through the windows of the houses in the middle of the street. The people got into their uppermost rooms, where they had the melancholy prospect of a perfect sea in the street: horses, cows, sheep and hogs and all manner of household goods floating ... There was one thing rather comical than otherwise happened in the midst of this doleful spectacle. A sow, big with young, had swum till her strength was quite exhausted; a wheelbarrow was carried by the torrent out of somebody's yard, which the sow being pretty near, laid her nose and forefeet into, and suffered herself to be carried by the flood till she got safe to land.

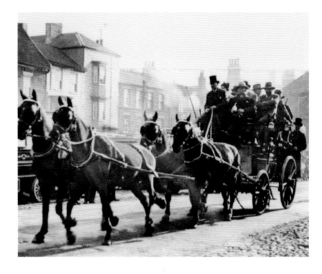

'Riding the fair' in 1930.

Bulmer's records the 1771 inundation:

> The water rose twenty feet above its usual level, and so rapid was the rise that the inhabitants, unable to escape, were driven for refuge to the roofs of their houses, from which they were removed in boats...some lives were lost.

The toll of the bell installed in the Dutch house in Yarm High Street was always an unwelcome sound: it's all too frequent doom-laden tolls warned of impending floods.

Egglescliffe and Eaglescliffe

Egglescliffe, as opposed to Eaglescliffe next door on the opposite side of the bridge to Yarm, got its name after a misspelling on the local railway station sign, in which the 'a' was accidentally substituted for the 'g'. There is no history of eagles living in either. In the 1870s the station, Eaglescliffe Junction, was extended to include four platforms, extensive sidings, and refreshment rooms, which were *the* place to meet in Eaglescliffe. Among the celebrities changing trains at Eaglescliffe was the opera star, Beniamino Gigli – one of the finest tenors ever – on his way north to a concert.

Cat Flaps at the Lyric

The Lyric Cinema used to be where Yarm Medical Centre stands today on Worsall Road. It burnt to the ground in 1959 but not before its resident cats had won for themselves something of a reputation for, often unappreciated, feline friendliness and familiarity. There are many who remember cats walking across the stage in front of the screen and women screaming when the cats brushed their legs during a film; the cats were renowned for sitting on the laps of the audience.

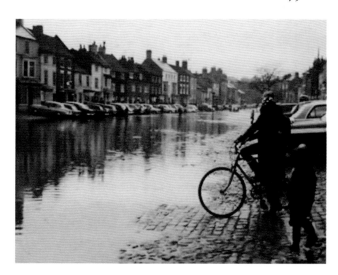

Yarm High Street during the 1968 floods.

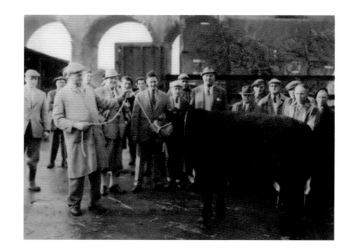

A fine beast at Yarm cattle show in 1960 with the viaduct in the background.

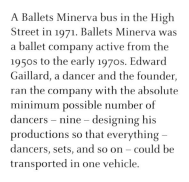

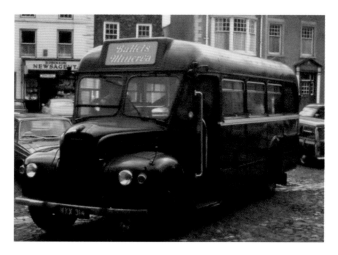

A Ballets Minerva bus in the High Street in 1971. Ballets Minerva was a ballet company active from the 1950s to the early 1970s. Edward Gaillard, a dancer and the founder, ran the company with the absolute minimum possible number of dancers – nine – designing his productions so that everything – dancers, sets, and so on – could be transported in one vehicle.

Redcar

'Bracing' Redcar

Coatham, swallowed up by Redcar today, was a medieval port, to which a market and fair were granted in 1257. Redcar was originally the lesser place, described as 'a poore fishing toune'. Samuel Gordon gives us an early description of Redcar in his *The Watering Places of Cleveland*, 1869:

> Advantageous in an eminent degree as a marine resort ... in immediate proximity to the beach, is exposed to the full play of the bracing sea breezes, while at the same time it is so far removed from any of the great ironworks ... as to be entirely beyond the influence of their unsalutary effects. Redcar and Coatham were formerly separated from each other by green fields.

In 1890 *Bulmer's* echoed the praise, and the euphemism that is 'bracing':

> The village is situated on a rocky bend of the coast a few miles south of the mouth of the Tees. Formerly it was an obscure hamlet inhabited by fishermen, whose avocation was here fraught with more than the usual danger, from the rocky nature of the coast. In recent years it has risen into favour as a seaside resort, and is much frequented by the inhabitants of the North Riding and the neighbouring county of Durham; but,

A busy Redcar High Street in the early 1900s.

despite the several attractive hotels and lodging houses that have been erected, it retains much of its old-fashioned appearance. It possesses, however, unequalled advantages for sea-bathing; its air is bracing, and the sands, some ten miles in length, are 'as smooth as velvet, and yet so firm that neither horse nor man leave their imprint on them as they tread the strand.' Beneath these sands were discovered a few years ago the remains of an ancient forest, embedded in peat and blue clay. Several large trees were found, and the peat was carted away for use.

Estuary Development

This is a civil engineering triumph. Building started on the 22 miles of training walls from Middlesbrough to Newport in 1861. The aim was to provide a safe and efficient harbour; the Tees estuary was dredged so that ships serving the new iron and steel foundries could operate more efficiently and safely. Blocks of solid blast furnace slag were positioned along the banks then back-filled using 70,000 tons of material dredged from river bed. This in effect canalized the estuary, allowing it to clean itself by the ebb and flow and tides. By the end, five million tonnes of blast furnace slag and 18,000 tonnes of cement had been used. By the end of the century 2,500 acres of mudflats had been reclaimed as dry land. On the north shore a similar exercise between Haverton Hill and Port Clarence and at Greatham Creek achieved much the same. The gares were added later. The Tees Conservancy Commission, whose project it was, built a dry dock at South Bank in 1876.

Warrentown and Dorman Long & Co

Iron and steel came to Redcar in 1873 when Downey & Co. built the Coatham Iron Works 1 mile from Coatham; Walker, Maynard & Co then built four furnaces at the Redcar Works employing around 200 men. In 1873 Robson had replaced Walker and built Warrentown – a new village of 200 or so good houses in terraces of seven with

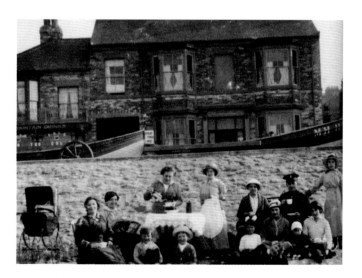

A happy day out in 1917 on Redcar Beach.

small gardens and a fence. Allotments were also laid out for the cultivation of potatoes and the keeping of pigs. Streets were Todd Point Road, Downey and Coney Streets. The name was changed to Warrenby to make it more in keeping with the Danish antecedents and the villages around which shared the suffix 'by'. The Dorman Long & Co. steelworks were built in 1916–17 after Dorman Long had taken over the old Warrenby Works and introduced new mixers, furnaces and plate mills. At its peak the works employed over 5,000 men; Redcar's 'Garden City' was built at Dormanstown for the workers.

Dormanton

The village included houses for the elderly – the first in the United Kingdom. A road to a proposed new railway station and footpaths across the marsh to Warrenby and the Redcar Iron Works, a hospital, chapel, library and technical school never got off the ground. Building took place between 1917 and 1920, helped by a light railway from the works to bring in materials.

The Warrenby Boiler Explosion

The horrific thirteen boiler explosion at Walker, Maynard & Co.'s Redcar Iron Works in Warrenby occurred on 14 June 1895 when eleven workers died and eleven others were seriously injured. The disaster led to concerted charitable efforts to compensate those affected and made good the inadequate assistance provided by friendly societies – the only insurance available to most at the time. After a series of fund-raising events the fund was able to pay widows 2s 6d, 1s 6d to orphans under ten years and 2s to orphans over ten and under fourteen. The injured were similarly compensated. This is how the *North Eastern Daily Gazette* reported the disaster the next day:

> AWFUL EXPLOSION NEAR REDCAR. THIRTEEN BOILERS BLOWN TO PIECES. FRIGHTFUL WRECKAGE. TEN MEN KILLED AND MANY INJURED. MIRACULOUS ESCAPES. LARGE IRONWORKS DESTROYED. 200 MEN THROWN IDLE.

Fishing

The second edition of Walbran's *Visitor's Guide to Redcar* in 1848 tells us that there were thirty-six cobles manned by around 100 men and boys: the larger ones required five men and were 46 feet long. Price of a coble, usually built in Hartlepool, would be around £35 at a cost of 12–15 guineas. Before the 1840s it was common for three men to share a boat. As today, fish was sold on the beach but exports extended to West Yorkshire and as far afield as London when the railway came. There were also fifteen or so pilot boats at Redcar servicing traffic to Stockton, Middlesbrough and Hartlepool.

The Gaunt family had a salmon fishery from 1830 in Coatham Bay and the Tees Estuary; ducks were caught using decoy nets on Coatham Marshes.

The Railway

A meeting at the Crown & Anchor discussed the urgent need for the extension of the railway line from Middlesbrough to Redcar. Without it, the resort would lose the burgeoning tourist trade to Seaton Carew and Hartlepool; with it, holidaymakers and day-trippers could get to Redcar conveniently and relatively quickly. Lucrative local fish could be exported further afield and in greater quantity; coal would come down markedly in price – the price of 10s per ton in Middlesbrough was 7s 6d more in Redcar when the additional transport cost was taken into account and the cost of rail freight was only 2s per ton. Trains would permit commuting to other parts of Teesside for the professional classes; commercial travellers could come and go.

On 8 June 1846 the line was opened to great ceremony with Stephenson's locomotion hauling fourteen wagons of coal and lime, followed by GNER's *A* pulling twenty coaches full of jubilant passengers. A huge milestone for Redcar.

The original station was at the junction of Queen Street and West Terrace, but in 1861 a new station was opened in 1861 and the line was extended to Saltburn. Alexander Coverdale took on most of the old station and created a market there. He was a resourceful man with interests in drapers, a gift shop, jewellers and a watchmaker, a circulating library and a printers and stationers. Another Coverdale, David, was to show equal resourcefulness some 100 years later. The old station became a theatre in 1893 and staged a D'Oyley Carte Co. production of *The Mikado;* later it was the Central and Regent cinemas, the former destroyed by fire in 1948 and not reopening until 1954. Both were demolished in 1964.

Redcar People

By 1851 half the people of Redcar had been born there, 30 per cent came from the North Riding and the rest from County Durham. Most of the immigrants came from nearby Guisborough exchanging agriculture for industry as a means of making a living. Many too came from Stockton. In Coatham, 40 per cent of the people were born and bred there. One fifth of Redcar men were fishermen, another fifth were in the building trade – a reflection of the building boom; half that were farmers; another twelve per cent were pilots. Widows often took on lodging houses. In Coatham it was different: over 35 per cent were in agriculture with no fishermen other than eight salmon fishers.

Commercial and Social Redcar

As we have seen, the commercial essence and activity of a town is reflected in its trades, professions and shops. The 1890 edition of *Bulmer's Directory* gives us the following information about life then in Redcar:

> There were two booksellers and stationers; two printers and stationers; eight boot and shoe makers; five butchers; five dressmakers and milliners; four fancy repositories; two fishmongers; thirteen grocers or greengrocers; three tailors; five coffee and cocoa refreshment rooms; two ironmongers.

Newspapers to read were: *Redcar and Saltburn News* (1870), Saturdays; *Redcar and Saltburn by the Sea Gazette* (1861), Saturdays.

The many hotels, inns and taverns were as follows:
- Alexandra, Portland Terrace, William Connell
- Clarendon Hotel, High Street, Thomas Jones
- Crown & Anchor, High Street, Henry Harland
- Globe Hotel, 80 High Street, Wm. Weatherill
- Jolly Sailor, 108 High Street, George Fall
- Queen's Hotel, 22 High Street, John Bell
- Red Lion Hotel, High Street, George Mark Clay
- Royal Hotel (vacant), Esplanade;
- Stockton Hotel, 122 High St., Jemima Lloyd
- Swan Hotel, High Street, Mrs. Christiana Rogowski
- Zetland Hotel, High Street, Thomas Atkinson

And forty-three lodging houses.

Cholera and Typhus

September 1854 saw cholera visit Redcar with twenty cases and eight deaths, seven of which were clustered in squalid Fishermen's Square, owned by the Earl of Zetland. The Earl immediately demolished the houses and built a new street, South Terrace, for the fishermen: twenty-two terraced houses 'with every sanitary improvement to prevent the recurrence of the disease'. Then came typhus with thirty cases and one death in Back Lane; there were also two deaths in North Side. The resulting Ranger Report concluded that much of Redcar was a dirty, fetid, insanitary place, somewhat at odds with the eulogies found in the travel guides. Springs and wells were often polluted with seepage from cesspits. There were no scavengers – the men who emptied the privies and ash pits by night; refuse was simply thrown into the road or heaped up. In June 1855 the Redcar Board of health was set up to remedy this calamitous situation. Enteric fever struck in 1890 and 1891; the filth and squalor we saw forty years previously had not been eradicated and was the cause. The Kirkleatham board of health reported 'large accumulations of filth of every description such as ash pit refuse and human excrement from privies and closets ... it is certain that all the filth will be washed into the stream ... and carried to the Stockton and Middlesbrough pumping station'. From August 1893 the region took its water supply from the clean water of the reservoir at Lockwood Beck leaving the local water board high and dry.

Zetland School

Built in 1859, the school suffered badly from poor attendance. Every summer the older girls would be kept home to do household chores; boys would be hired to run errands for the shops or do donkey rides. Shipwrecks were a spectator sport often requiring salvage recovery boys and girls, which meant many absentees, as did Redcar races and the Regatta and fair days. Sadly, in 1870, smallpox claimed four young lives in one week

and led to the closure of the school for one month. It was closed again in 1874 when scarlet fever ravaged the town.

Coatham Pier

Finally completed in 1875, the pier was intended to extend over half a mile out to sea – 700 feet longer than the pier at Redcar. The costs of repairing it after damage caused by the brig *Griffin* and the schooner *Corrymbus,* which both collided with it during construction, restricted the length to 1,800 feet. It featured a glass pavilion halfway along in which orchestras played – in contrast to the brass bands which performed along the coast at 'down-market' Redcar. A mobile bandstand shuttled between Redcar and Coatham – the result of the two towns' inability to compromise on a shared facility. In 1898 the barque *Birger* sailed straight through Coatham pier leaving the glass pavilion in splendid isolation out at sea. The captain and chief officer were both killed by the falling masts; only two out of a crew of fifteen survived. This disaster put the Pier Co. out of business and brought about the end of the pier at Coatham.

Redcar Pier

Built by the Redcar Pier Co. to provide 'a commodious promenade and landing pier' in 1871 largely in response to the construction of the rival pier in Coatham. It stood opposite Clarendon Street, extended to 1,100 feet and was 114 feet wide at the pier head. It featured sheltered seating for 700 people, a bandstand and a landing jetty for the Whitby to Middlesbrough pleasure steamers. Damage from colliding ships and the 1898 bandstand fire after a concert party blight its history; the Pier Pavilion dance hall was built in 1907. *Bulmer's* again in 1890:

> A fine esplanade, 30 feet wide and half a mile long, was constructed along the beach a few years ago, at a cost of £2,500, forming a delightful promenade; and more recently two promenade piers have been erected, one in Redcar, and the other in the adjoining village of Coatham. Bathing machines have been plentifully provided, and for those who either from nervousness or debility fears to face the waves, there are hot and cold sea-water baths at moderate charges ... There is excellent hotel and lodging-house accommodation, and many streets of very superior houses have been erected.

Locke Park Bombed, Mayoress Falls into Lake

The park was opened in 1929 by the Mayoress of Redcar, Mrs B. O. Davies. Col. Thomas William Spink Locke, a Redcar benefactor, left £5,000 in his will to the borough council to buy 24 acres of land for a public park for the delectation of the people of Redcar. It took 120 men to excavate the lake. The original plans included a fountain on the island, a croquet lawn and a bandstand but these never got beyond the drawing board. The Braille Garden did, however. The opening ceremony was attended by five neighbouring mayors and mayoresses in boats; one of them, Mayoress Metcalfe, fell unceremoniously from her boat into the lake. The park was opened again in 1930 by the mayor, John Emerson Batty, to mark

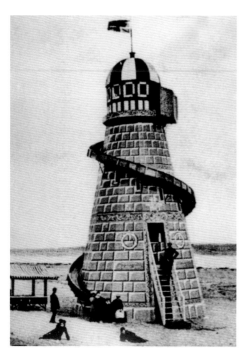

Newsome's Helter Skelter Lighthouse around 1907.

the fact that it was actually finished. Or was it just male chauvinism? During the Second World War the park was bombed and the bowling green took a direct hit. Nevertheless the green was restored within a week, the crater was filled in and normal play resumed. Did the Luftwaffe pilot know that the boathouse was the headquarters of the ARP? Even more oddly, a bomb landed in Coatham churchyard causing damage to Col. Locke's grave – more impressive German intelligence, and precision bombing.

Peg Leg Peggy

The Pleasure Park off West Dyke Road (now Buckingham and Sandringham Roads) boasted the largest Giant Racer, Figure of Eight, or 'Mad Mouse' as it was known locally, outside London when it opened in 1925. Other popular features at the Pleasure Park included Noah's Ark Roundabout, the House of Fun in which there were crazy walks and distorting mirrors, the Giant Slide and the Tunnel of Love. Peg Leg Peggy was a one-legged (cross-dressing?) stuntman/woman who would dive into 4 feet of water from a 70-foot tower, but not before setting him/herself on fire.

The Sand Gets Everywhere: Lewis Carroll

Carroll stayed in nearby Granville Terrace; it seems likely that some of the 'Walrus and the Carpenter' from *Alice in Wonderland* was inspired by the troublesome shifting sands here: 'They wept like anything to see such quantities of sand, Oh! Only if it was cleared away, well wouldn't it be grand.'

Dickens' Bleak View

Charles Dickens, on a brief visit in 1844, described Redcar and Coatham as 'a long cell' and apparently took one look at it before getting straight back on the train to Marske. Less precious visitors included Samuel Plimsoll (of Plimsoll line fame) and novelist Nathaniel Hawthorne – author of *The Scarlet Letter*, among other novels. In 1859 Hawthorne stayed in the Clarendon Hotel and then in lodgings, looking for of peace and quiet, while writing *The Marble Faun*. Hawthorne's house is on the junction of High Street and King Street, formerly known as the Hawthorne Cafe. Plimsoll hit on the idea of the life-saving line which bears his name when he saw the so-called 'coffin ships' off the coast – battered old tubs which were often badly overloaded and frequently sank as a consequence. The Plimsoll line became a legal requirement under the Merchant Shipping Act of 1876.

The Stead Memorial Hospital

The Stead (formerly Everdon Villa) was bequeathed to the people of Redcar by Dr M. F. Arnold Stead in 1929 for use as a seven-bed cottage hospital in honour of his late father, the metallurgist Dr John E. Stead who had specialised in the extraction of iron from its ore working for Bolckow & Vaughan Iron Works.

Donkey Races

The flat and firm sands of the beach were ideal for horseracing and training, and so they were used until the opening of the racecourse in 1872. Like Hartlepool up the coast, Redcar had a brief flirtation with life as a spa resort – Dr Horner's Hydropathic Establishment was set up in 1850 on the Esplanade where visitors could enjoy the delights of cold saltwater bathing and 'cure all ills'. Dr Horner ran a spa at No. 86 Nymphenburgstrasse, Munich. Nearby Graffenberg Street was named after the then Silesian (now Czech) town of

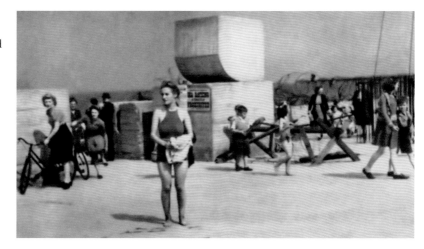

During the Second World War parts of Redcar Beach reopened for the season in 1943 via the slipway opposite Moore Street. Bathing and boating were prohibited. The coastal defences, of course, were very much still in evidence.

Graffenberg where hydrotherapy treatment was pioneered by Vincenz Priessnitz in 1826. He is also famous for locating the 'g' in G Spot.

Uncle Tom's Sunshine Corner

Sunshine Corner was a popular attraction here from the 1920s; it was hosted by 'Uncle Tom' (and his concertina) who delivered a Christian message aimed mainly at children. They were invited on stage to recite a poem, read a short passage from the Bible or sing a hymn. The reward was a stick of Redcar rock. The 'Sunshine Corner Song' went as follows:

> Sunshine Corner oh its jolly fine
> It's for children under ninety-nine
> All are welcome, seats are given free
> Redcar's Sunshine Corner is the place for me.

Redcar Racecourse

Racing was originally held on the beach where a bathing machine served as the judges' box while the stewards sat on a farm wagon. The first meeting at the racecourse was held in 1872 on land leased out by the Newcomens. The grandstand was built in 1875 and the course extended. The racecourse was regularly used by various regiments for training and camps; the Cleveland Agricultural Show also had it as a venue from 1833 up to 1966 when an outbreak of foot and mouth disease ruined that year's show, a crisis from which it never recovered. *Bulmer's* sings its praises in 1890:

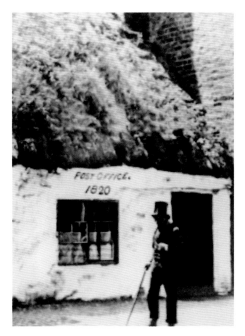

Redcar's first post office opens at No. 38–40 High Street near the Red Lion Inn; it was a timber-framed cruck.

It is a fine level piece of ground covering upwards of 100 acres, giving a straight course of one mile and a 'distance' of 240 yards. There are stables for thirty-nine horses, and a spacious refreshment room has been added recently. Races are held twice a year.

The Emma Dawson and the Lifeboat Window at All Saints' Church, Weston

The *Emma Dawson* features, unusually, in a window in All Saints church in Weston, near Otley. It was commissioned by the National United Order of Free Gardeners to honour Emma Dawson of Weston Hall after she died in 1880. The Redcar lifeboat crew of the time reciprocated by erecting a wall tablet in gratitude for her support. The death of her husband had made her a wealthy widow and a benefactor of some repute. Every Whit Monday she would come to Redcar where she became well known for her generosity and public spiritedness, particularly towards Redcar's fishermen and their families. In 1858 the existing lifeboat, the *Zetland*, was consigned to the scrapheap by the RNLI although, after much local protest, they relented and allowed the townspeople to make repairs and keep her in service. The problem would not go away, however, and the RNLI persisted in their efforts to replace the *Zetland*. However, the Free Gardeners intervened in 1875 to raise money for a new boat, designed along the lines of the *Zetland*, much to the annoyance of the RNLI who had their own designs. A £600 non-RNLI specification boat, and a £700 boathouse with fishermen's clubhouse above, was duly built with substantial donations from Emma Dawson and Lord Zetland. The launch took place in 1877 before nearly 20,000 people.

The Zetland

The oldest lifeboat in the world, the thirteen-man-crew *Zetland* was built by Henry Greathead in 1802 and was in service for seventy-eight years during which time she saved over 500 lives, for the loss of one crew member, William Guy on Christmas Day 1836. Double ended to obviate the need for turning round, the 30-foot, very shallow boat was made from English oak and larch; her gunnels were lined with cork for buoyancy. A local farm provided up to nineteen horses for the launches. After a long and circuitous voyage she now resides, thoroughly restored, in the Zetland Museum in Redcar.

Thomas Brown – The Valiant Dragoon

Private Tom of the 3rd Hussars was born at Kirkleatham on 25 June 1710. His father owned a cottage in Kirkleatham next to Sir William Turner's Hospital, founded in 1676. Tom showed extraordinary courage at the Battle of Dettingen in 1743 in Bavaria during the War of the Austrian Succession. The thrilling citation for his knighthood reads as follows:

> He had two horses killed under him, two fingers of his bridle hand chopped off and, after retaking the standard from a gentleman at arms, whom he killed, he placed it between his legs and the saddle and made his way 80 yards through a lane of the enemy, exposed to fire and sword of the enemy in the execution of which he received eight cuts

The wonderful window at Weston.

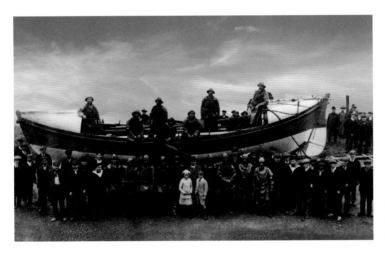

The *Fifi* and *Charles,* which saw service between 1907 and 1931.

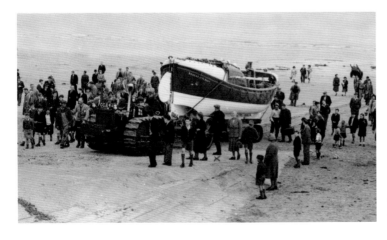

The City of Leeds Lifeboat in the late 1950s.

in his face, hands and neck, 2 balls lodged in his back, 3 went through his hat, and in this hacked condition he rejoined his regiment, who gave him three huzzas on his arrival.

At Dettingen, George II became the last English monarch to lead his army into battle. The heroic Tom Brown was the last man to be knighted (as a knight banneret) on the battlefield. Two years after Dettingen the people of Kirkleatham planted an elm tree outside the hospital gate with a plaque commemorating Tom's exploits. When it died, an oak was planted in its place but the plaque had vanished, happily replaced in the 1940s. Tom was buried in Yarm in 1746 in St Mary Magdalene's church where his grave is marked with a replica of a Commonwealth War Graves Commission headstone, presented by the Queen's Own Hussars in 1968.

A banneret was a commoner of rank who led a company of troops in battle under his own banner; the military rank of a knight banneret was higher than a knight bachelor (who fought under someone else's banner), but lower than an earl or duke.

'Titty Bottle Park'

'Titty Bottle Park' was laid out in 1905 on the promenade near the bandstand and named by a comedian. The name refers to the nannies that brought infants there to sit down and feed. It was triangular in shape, gated and surrounded by a metal fence. Flower beds in the shape of suits of cards brightened it up nicely. There was a Titty Bottle Park too in Otley, named presumably for the same reason.

Lemon Tops

Redcar is rightly famous for its ice cream. The most prolific manufacturers and shops down the years have included Pacitto's, Todisco's, Rea's, Burniston's and Kings, who also made and sold Redcar Rock. Pacitto's ran two ice cream parlours; their signature cone was the 'lemon top' which comprised ice cream in a cone, with a dollop of lemon sorbet on top. They also ran the Stray Café, an ice cream factory in Redcar, and an ice cream shop in Scarborough. Mr Todisco was one of the many local Italians sent to Canada during the war. Unfortunately he drowned when his ship was hit by a German torpedo. Rea's best years were in the 1970s when they employed more than 200 people and had twenty-one snack bars in the region as well as a factory in Cargo Fleet. Chris Rea, son of the founder, Camillo or Camy, promoted his debut single, 'So Much Love', with a sleeve photograph showing him posing with a 'Stop Me and Buy One' bike.

Gertrude Bell and the Hashemite Dynasties of Jordan and Iraq

Gertrude Bell (1868–1926) was a writer, traveller, archaeologist, linguist, Alpine mountaineer and spy who had a great influence on British foreign policy-making in what was Greater Syria, Mesopotamia, Asia Minor, and Arabia. Along with T. E. Lawrence, Lawrence of Arabia, Bell helped establish the Hashemite dynasties in what is today Jordan and Iraq. She established the National Museum of Baghdad and reached places never visited by a Western woman. Bell has been described as 'one of the few representatives of His Majesty's Government remembered

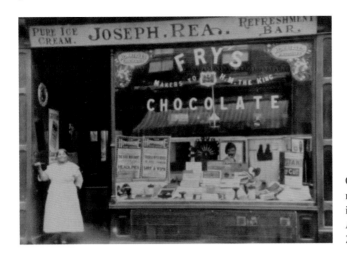

One of the many Rea's refreshment bars. This one is in Fore Bondgate in Bishop Auckland. It later became Zair's Café.

by the Arabs with anything resembling affection'. To them she was a great sheik; many Arabs attended her funeral; one asking in tribute, 'If this is a woman, what must the men be like?'

Her grandfather was the Teesside ironmaster and Liberal MP Sir Isaac Lowthian Bell. Her stepmother, Florence Bell, was a great influence on her and it is likely that her work with the wives of Bolckow Vaughan ironworkers in Eston would have informed Gertrude's active promotion of education for Iraqi women. From the age of two she lived at Red Barns House in Kirkleatham Street, Coatham, now the Grade II listed Red Barns Hotel, until she went up to Oxford where she read history, winning a first after only two years – the first woman to win a history first. Her father, Sir Thomas Hugh Bell, was a director of Bell's steelworks and a director of the North Eastern Railway. In 1933 Colonel Sir Maurice Bell of Mount Grace Priory unveiled a portrait of his sister Miss Gertrude Bell at the Redcar Literary Institute, 'the celebrated scholar, peer, historian, archaeologist, art critic, mountaineer, explorer, gardener and naturalist'. Gertrude Bell delivered some of her first lectures at the Institute. In his address her brother said: 'She had a love for Redcar, and all her life had a feeling that Redcar was her home.'

The Acoustic Mirror

To the south-east of Redcar there was an aircraft listening post built in 1916 as part of a regional defence system to detect approaching aircraft and Zeppelins, and give due warning. It is an acoustic mirror; these were widely used before the invention of radar. Only the concrete sound mirror remains, as a Grade II listed building.

Redcar Jazz Club

The Redcar Jazz Club was one of Britain's foremost rock, jazz and rhythm, folk and blues venues of the 1960s and 1970s. Jazz acts included Kenny Ball and John Dankworth while the roll call of artists appearing in the sixties and seventies was nothing short of magnificent, from T.Rex to Free, from the Who to Sandy Denny, from Cream to Pink Floyd and the Moody Blues. Life for the Redcar Jazz Club started off at the Royal Hotel,

Gertrude Bell aged eight and her father in a painting by Edward Poynter (1836–1919).

moved to the Red Lion and then finally the Windsor Ballroom at the Coatham Hotel. The end of the road came in 1973, marked by the cancellation of a concert by Wizzard.

'Redcar scrubs up for starring role in film version of *Atonement*'

So said David Hencke in *The Guardian*, 24 May 2006. He went on:

> The film will also cover the boyfriend's horrors of the Second World War during the evacuation of Dunkirk. It is this that has given a starring role to the coastal town of Redcar. The production company, Working Title, searched the country for a town that could still pass for Dunkirk in the 1940s – and the only place that fitted the bill was the undeveloped beach and esplanade at Redcar ... Redcar and Cleveland borough council will allow the company to take over the town's beach turn a terrace house into a French bar and replace railings and lampposts with authentic French cast iron versions. It will also be featuring half-sinking tanks in the sand and bringing in a flotilla of small sixty year old boats. For the local Teessiders, there are 1,000 parts as film extras playing the departing squaddies and the chaos of war.

The Beacon

The Beacon opened in March 2013 and is the tallest building in Redcar at 80-feet (24m) high and has seven floors; there are 132 steps – and a lift; the foundations are 15m deep; the cafe and open roof terrace have 360 degree views; it has a heat recovery system and solar reflective glazing.

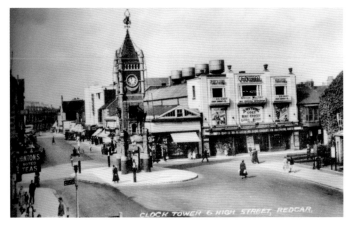

The famous clock tower from 1912 commemorating Edward VII in the mid-1940s; *Anything Goes* with Bing Crosby is on at the Central Picture House, which burnt to the ground in the late 1940s. The white building to the left of the clock is the Regent Dance Hall.

Andrew (on the right) and Jonathan Musgrave on the set of *Atonement* – two of the hundreds of Redcar residents who played their part as extras.

A sunset scene on the set of *Atonement*.

Above: The Beacon – with those wind turbines in the background enhancing the view.

Right: Rooting around in the rock pools in 1900.

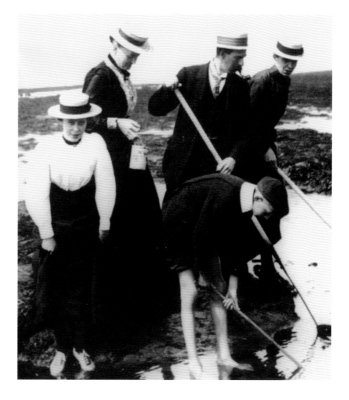

Also Available from Amberley Publishing

This fascinating selection of photographs traces some of the many ways in which Central Middlesbrough has changed and developed over the last century.

Paperback
180 illustrations
96 pages
978-1-4456-1060-3